Experimental
Flowers
in watercolour

Ann Blockley

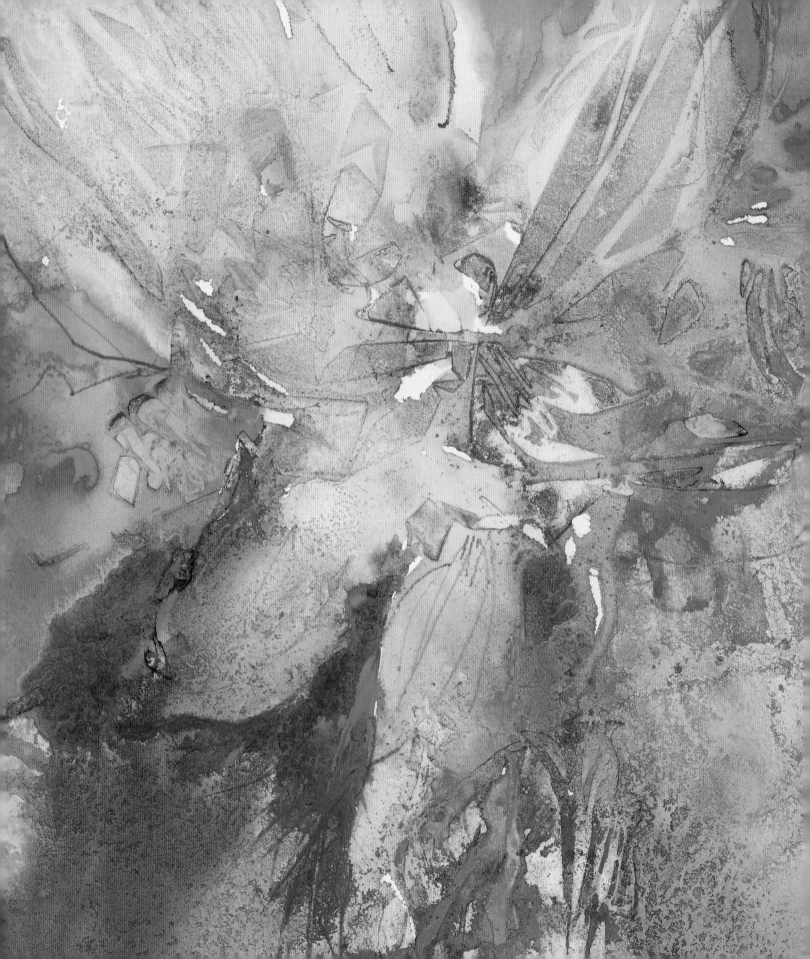

Experimental
Flowers
in watercolour

Ann Blockley

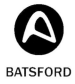

BATSFORD

First published in the United Kingdom in 2011 by

Batsford
10 Southcombe Street
London W14 0RA

An imprint of Anova Books Company Ltd

ISBN: 978 1 906388 77 5

A CIP catalogue record for this book is available
from the British Library.

18 17 16 15 14 13 12
10 9 8 7 6 5 4 3

Reproduction by Mission, Hong Kong
Printed by 1010 Printing International Ltd,China

This book can be ordered direct from the publisher
at the website www.anovabooks.co.uk, or try your
local bookshop.

Distributed in the United States and Canada by
Sterling Publishing Co., 387 Park Avenue South,
New York, NY 10016, USA

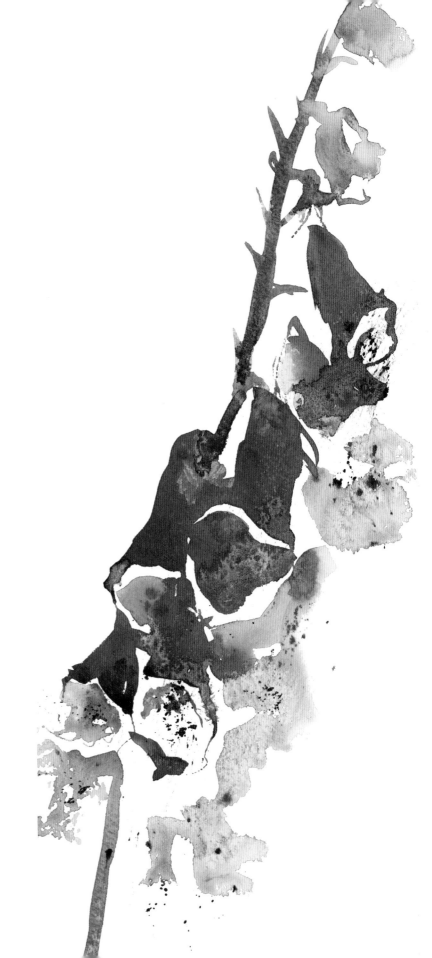

Contents

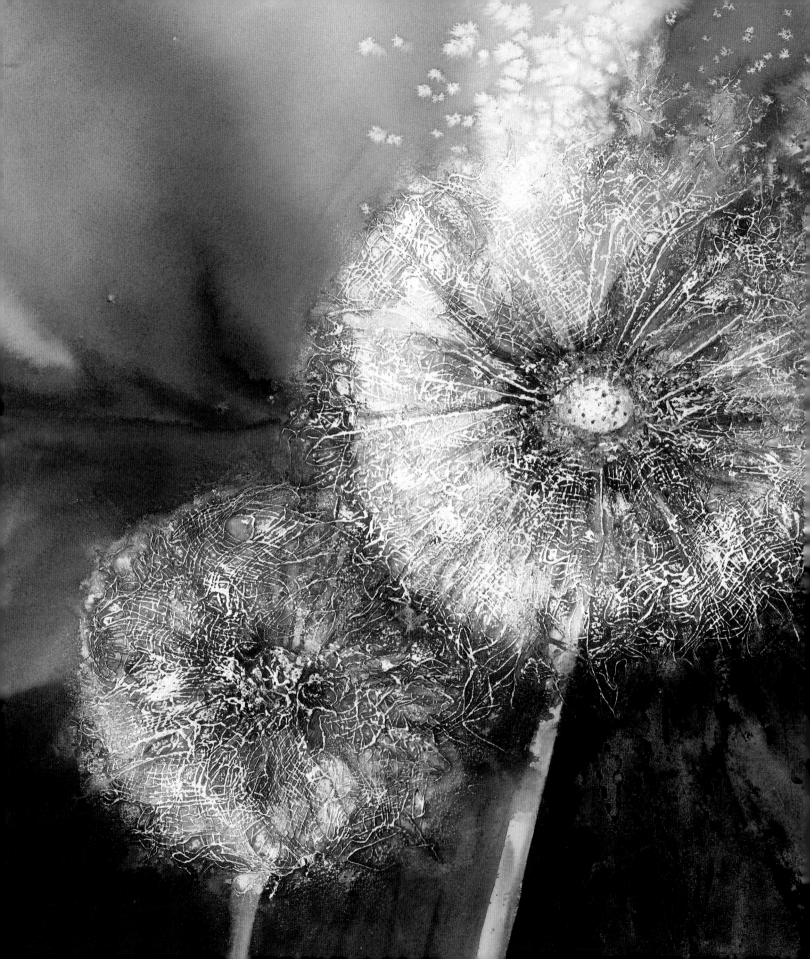

Introduction

With their incredible variety of colour, form and pattern, flowers make wonderful subjects. My aim in this book is to find creative and up-to-date ways to describe this popular subject matter. I look at the abstract qualities of flowers and interpret these in painterly experiments that stretch the boundaries of watercolour beyond its traditional image. I also hope to encourage and inspire you, through my personal creative journey, to discover your own expressive style, exploring the importance of moving on with your work and developing as an artist.

◀ **Blowing in the Wind**
55 x 55.5cm (21 ½ x 21 ¼ in)

Experimental flowers in watercolour

When I embarked on this book I had not planned a title, although I knew that it would involve flowers and watercolour. I decided simply to begin painting and see what developed. I soon realized that I was not content just repeating ideas that I had used before. Being an artist of integrity is an evolutionary process that involves constantly reassessing your work. Although I had my own idiosyncratic style, I needed a change and wanted to try painting in a more contemporary way. Even if I ultimately reverted to my usual methods, I felt that my work would be strengthened and refreshed by the challenge.

Like many artists, I am often beset by self-doubt and I knew that this journey might be a struggle. I was not sure how to find a new direction so I decided to spend a whole floral year experimenting with watercolour, flowers and ideas. My artistic journey became the underlying theme of the book and the title, *Experimental Flowers in Watercolour*, thus emerged.

My experiments combined familiar watercolour techniques with mixed media, different surfaces and collage. I also wanted to push boundaries in other directions, not just with the medium but also by edging away from painting only traditional representations and by finding ways to be more thought-provoking. I therefore explored ideas that would help me to look at subjects in a more progressive, imaginative and abstract way.

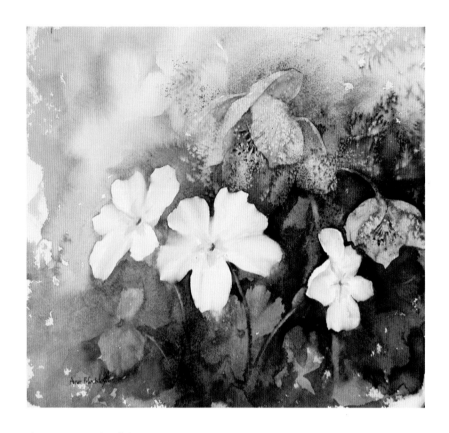

▲ **Primroses and Hellebores**

27 x 30cm (10¹/₂ x 12in)

I began the year painting within my comfort zone, experimenting with watercolour in a fairly loose way but in a representational style. This painting is a typical example. There is nothing wrong with it, but I can do this sort of work without any effort and I needed a change and a challenge, if only for a while.

Through the seasons

As I began the project in spring, I decided to arrange the book by season to split it into manageable chapters. These largely follow the sequence in which the paintings were made, as subjects appeared in my garden and the surrounding countryside. Throughout the year I revisited old themes in order to evaluate my progress, but as the months passed, I added an increasing number of new techniques and concepts to my repertoire. By the end of the year I was bursting with fresh ideas and ready to start applying some of the discoveries I had made to other subjects.

I have written this book in the form of a personal artistic journey. My aim is that, by sharing with you my thoughts, frustrations and achievements, you will be encouraged to be adventurous with your own experiments and develop your work in new and exciting directions.

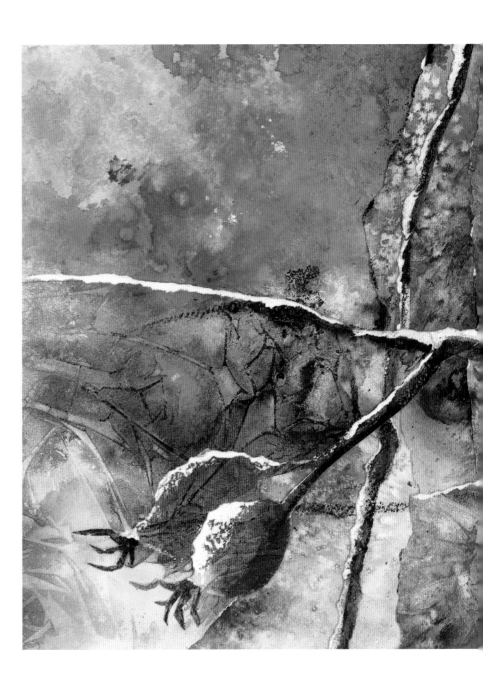

▶ **Frosted Rosehips (detail)**

By winter I was experimenting with many new ideas in my work. Some of these were based on techniques such as collage, some were to do with the medium or surface that I used, and, most importantly, I was beginning to look at my subjects in a different way and express myself in a more quirky, up-to-date fashion. See page 112 for the full painting.

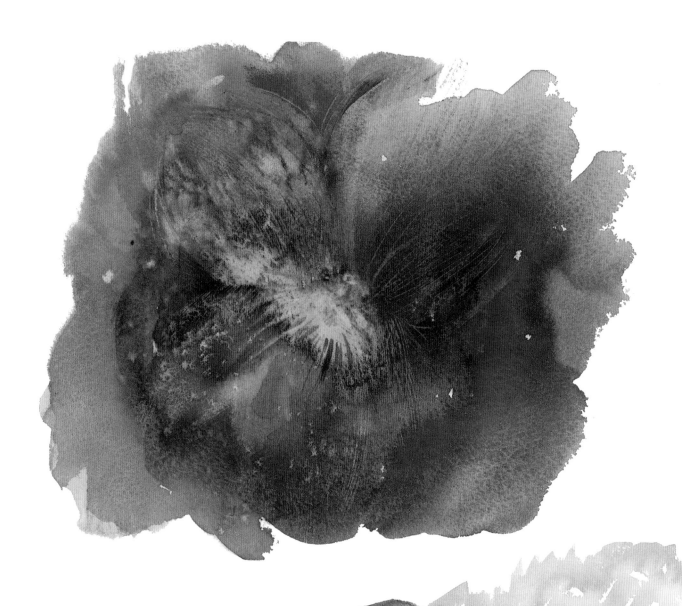

Paint experiments

Here is a selection of my watercolour experiments. They were made as preliminary colour sketches or loosening-up exercises before starting a painting, as I tried out different techniques to describe particular flower qualities.

Paint experiments

At the start of every painting session I loosen up with paint experiments. Playing with watercolour and surfaces to discover fabulous textures, edge values and marks is an endlessly fascinating process, which I view as being as important as making a finished picture to put in a frame. When faced with a blank piece of paper and a potential subject it is easy to feel confused by all the possible interpretations. To get creativity flowing, build confidence and firm up ideas it is essential to start by playing with paint.

Preliminary exercises

My first exercises may simply take the form of splodges or doodles to explore different colour combinations. Colour plays such an important role in a picture, especially when painting flowers, that it is absolutely essential to try out options before starting every painting. Within my explorations I also experiment with marks or textures, using a variety of techniques. I look for methods and combinations of media that best describe the characteristic of the flower that I have seen or the interpretation that I have imagined. Before I progress to a more planned composition I aim to loosen up both mentally and physically as this will be reflected in the painting. I describe my trial splodges as paint experiments, but although subsequent paintings may be more polished, they too are still part of an ongoing process of experimentation, not a finished product.

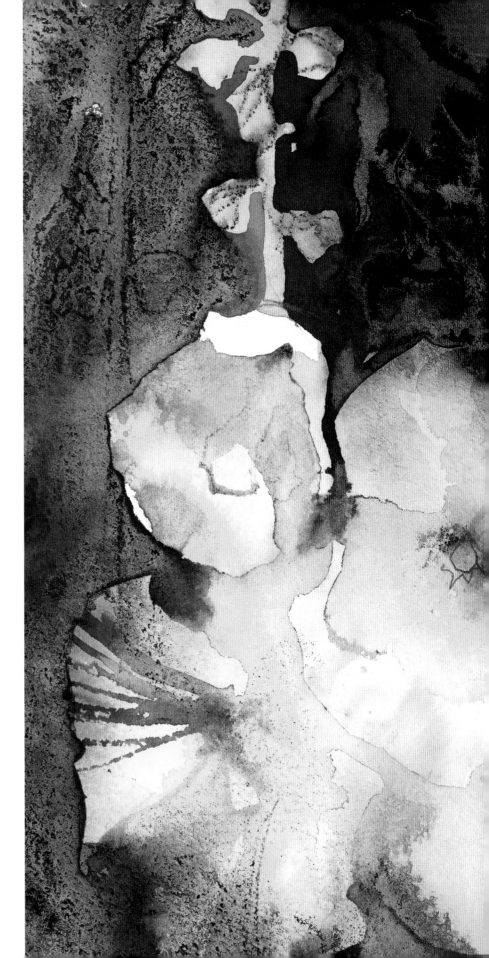

Watercolour and mixed media

In this book I look at ways of pushing the traditional boundaries of watercolour as well as enjoying the flowing translucency of the medium. The great thing about experimenting is that there are no rules. Ingredients such as salt or granulation medium can be added to watercolour to alter its character, and washes can be broken into textures by adding clingfilm or bubble wrap to the wet paint surface. Paint can be applied not only with brushes but also with a palette knife, toothbrush, roller or bits of card. Conventional rules about layering and allowing paint to dry can be ignored in favour of splashes, dribbles and backruns, manipulating paint, and rinsing away areas of colour with water.

Combining different media

Throughout the book I will be showing you my experiments with other media added either underneath or on top of the watercolour, including acrylics, gouache, acrylic inks, gold and silver inks, iridescent medium, wax crayon and oil pastel. The potential combinations of mixed media and the ways of applying them are endless.

▶ **Experiments**
Before I begin any painting I experiment with different media and methods. It is more important to me to find exciting marks and colours than it is to be entirely faithful to a subject. Methods include the use of clingfilm, salt, granulation medium, ink and washing out in conjunction with loosely applied watercolour washes.

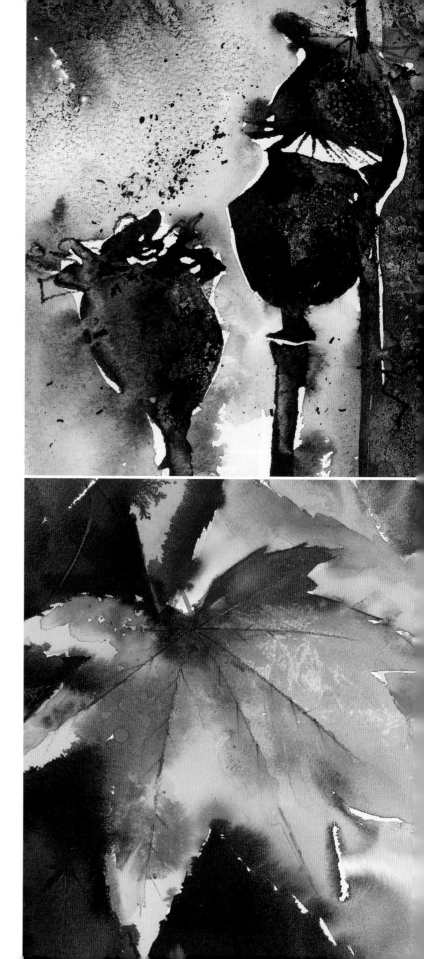

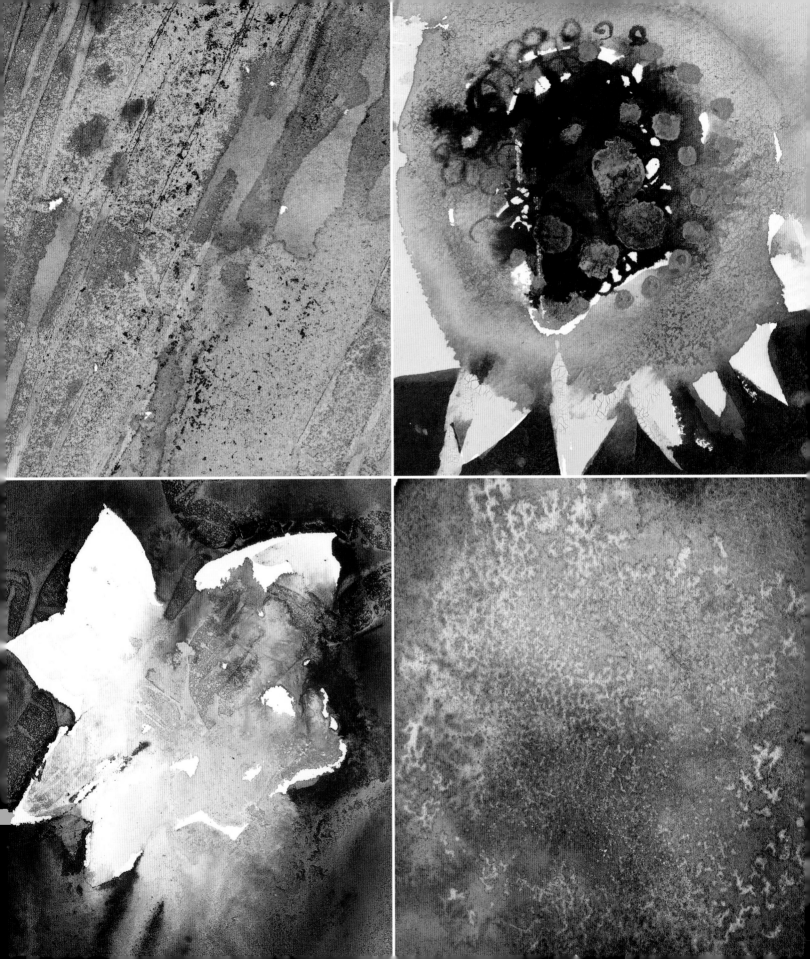

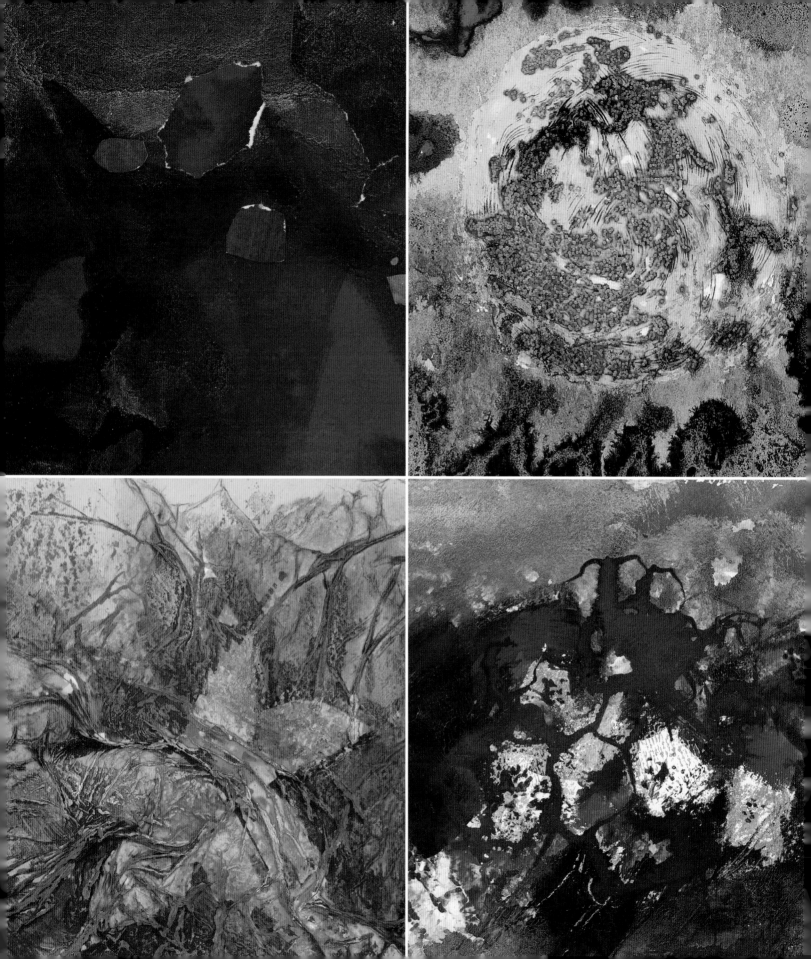

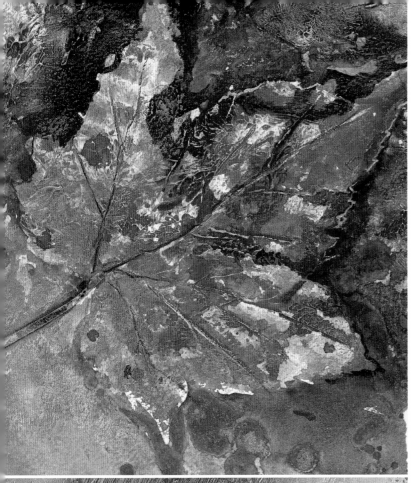

Surface textures

Many of the paintings in this book have been done on Saunders Waterford, Bockingford or Whatman watercolour papers in their various weights and using Not, Rough and Smooth surface types. Sometimes I distressed or changed the surfaces by scratching them with a scalpel, and cutting or tearing out shapes and holes, either to create surface texture or for the paint to sink into.

I also created my own varied surfaces by applying gesso or texture paste to different papers or mountboard with a palette knife, roller or stiff brush. You can add things to the gesso, such as tissue paper or sand, or use ready-made texture gels. Collages can be made using different types of papers and other materials, applied with PVA glue and then sealed with gesso, if necessary, before paint is put on top.

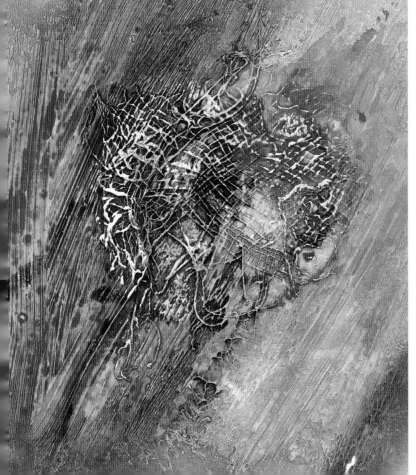

◀ **Experiments**
All the experiments shown here have been made on basic watercolour-paper surfaces that have been altered by the addition of other media or collage. Methods include the use of paper collage, glass-bead gel, tissue paper and gesso with oil pastel or gold paint on top, and scrim with coarsely applied gesso.

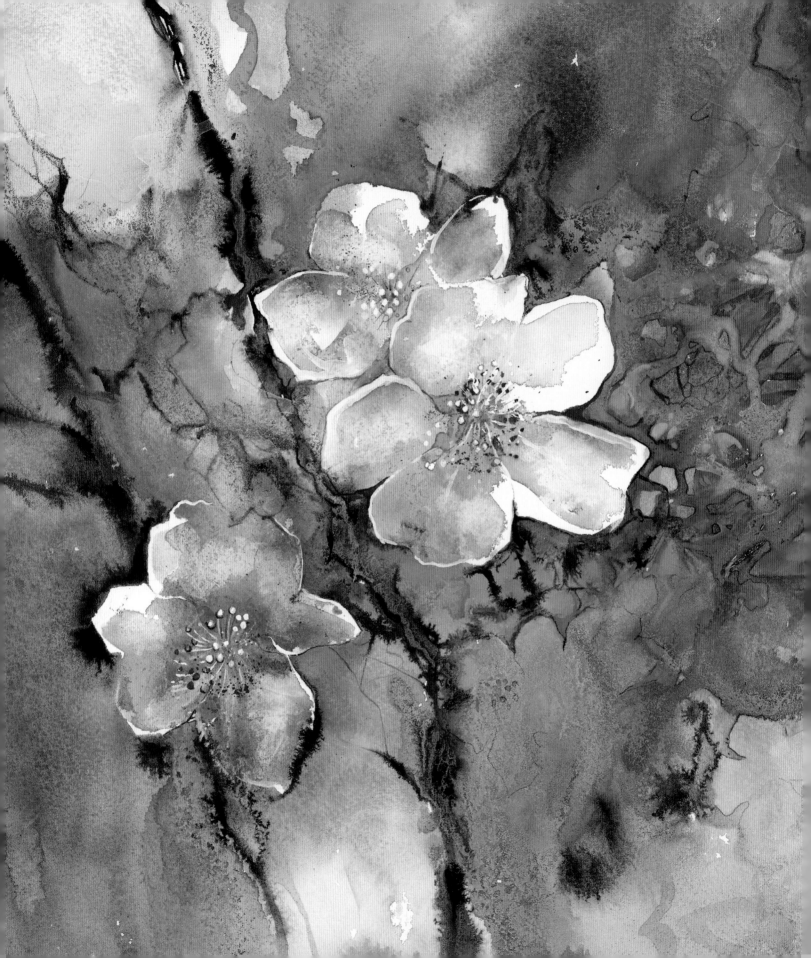

Spring

Spring is a time for new beginnings. When the first snowdrops herald the start of the floral year they bring a renewed sense of excitement, anticipation and resolve for the year ahead. It feels like the chance to make a fresh start with your painting. The often simple shapes and clean colours of spring flowers provide the ideal opportunity to begin experimenting with innovative concepts alongside reappraisals of traditional watercolour techniques and basic picture-making ideas.

◄ **Blossom and Lilac Time**
30 x 38cm (12 x 15in)

Exploratory sketches

When flowers appear in my garden I get really excited about the possibilities for painting them. I can find myself overwhelmed by all the decisions to be made regarding composition, colour and method. Before I can decide on any of these factors I have to discover what it is that particularly interests me in the plant. Is it, for example, its texture, markings or shape? Is it the actual flower that appeals to me or its leaves, or even its surroundings? Sometimes it is a mixture of things and at other times there is one quality that shines out above all the others.

Finding the point of interest

To help me to identify my main interests I begin a series of doodles and sketches, using whatever method or material seems appropriate. As a thought pops into my head, I experiment to try to capture it on paper. This may be an obvious quality that I have painted before or something more unusual or quirky. As these are private doodles, it is a great opportunity to let my hair down and have some fun. After making a number of experiments a certain aspect may emerge as the star quality and I will then explore this in more depth.

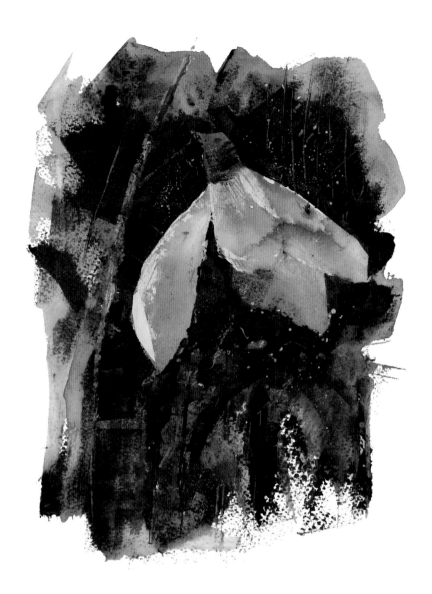

Snowdrop experiments
I used a variety of materials and methods in these sketches. One uses chunky brushstrokes of thick acrylic (above). The others are made with watercolour: one on top of crayon drawing, another broken up with clingfilm into ivy leaf shapes (opposite, top left and right), and one is simply a flowing, granulated wash (opposite, bottom).

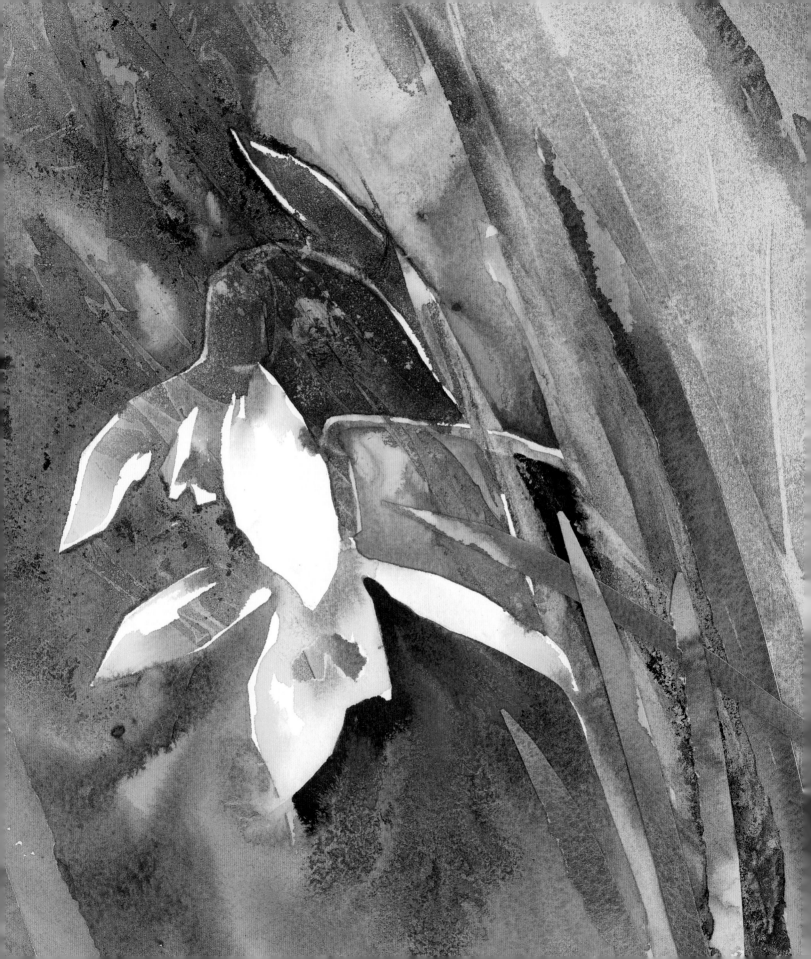

Finding inspiration

When I have made a number of exploratory sketches of my subject it begins to get clearer which aspects interest me most. However, sometimes it is not just the doodles that inspire me in a particular direction. Other factors can also play a role in the creative process. I may be influenced by another artist's work, a place I have recently visited, a colour combination seen in a fabric, the weather, or the mood I happen to be in. All facets of life have the potential to affect the development of a painting and inspiration can be gained from many varied sources. My artist's antennae are at work searching for ideas and inspiration all the time, not just when I enter my studio.

◀ **Snowdrops 1**
25 x 25cm (10 x 10in)
After the winter the spring greens seemed so bright that I was inspired to paint with vivid acrylic inks on Saunders Waterford 'High White' 300gsm (140lb) Not paper. This dazzling surface is perfect for painting snowdrops. I stuck strips of painted paper on top of preliminary washes to represent leaves and glued a tiny torn piece to describe each snowdrop's characteristic green markings.

Lost and found edges

In my year of flower painting the snowdrops bloomed among snow, ice and frost. Crisp white petals seemed to melt into soft white snow. The blade-like leaves echoed the spears of icicles that hung from wintry plants. I was inspired to look at the snowdrops in terms of their edge values and as opportunities to play 'hide and seek' with leaf and petal shapes. Where white met white, edges sometimes disappeared and shadows in the background often flowed into the flowers, fracturing their shapes. Methods such as traditional wet-into-wet watercolour are ideal for describing this lost-and-found effect.

▲ **Snowdrops 2**
17 x 15cm (6¹/₂ x 6in)
I like the way that clingfilm, when applied to a wet wash, can push the paint into ragged edges. This sort of edge is not really characteristic of a snowdrop, but the shadowy, fractured effect demonstrated in this little watercolour portrays a lot of mood.

Getting started

When I painted these primroses I was at the beginning of my year of flower painting and my search for new modes of expression. I realized that I would have to experiment in order to move on and find something different to say. At this stage, however, I was still enjoying some of my old themes, such as the contrast of smooth flowers against different coloured and textured backgrounds, and looking at how the composition is affected by moving the flowers around. I felt that I needed to revisit and reassess some of these traditional painting problems to set my new journey of discovery in progress.

Taking the first step

I find it helpful to begin painting sessions in my comfort zone, using my usual methods and seeing what new ideas evolve. If you feel stuck with your work, my advice is to stop thinking and simply begin painting. Put all your excuses and delaying tactics to one side and make the first leap. The creative juices will eventually begin to flow. Being indecisive can be debilitating. To overcome this I pick an idea from my sketches with the promise that I can begin another painting afterwards if there is justification for another version.

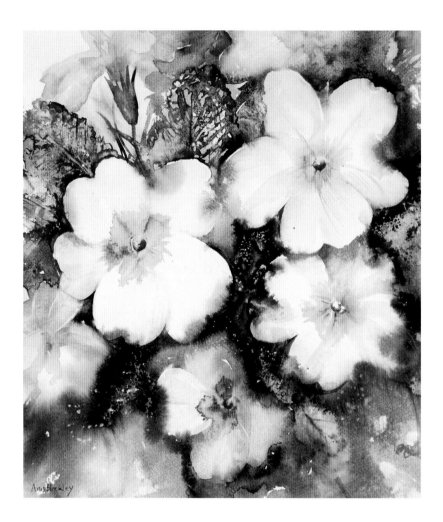

▲ **Primroses 1**
33 x 33cm (13 x 13in)
These flowers were painted on partially wet paper so that some of the petals blurred into the background washes. Leaves were made by scribbling on paint with a stick.

▶ **Primroses 2**
41 x 36cm (16 x 14in)
I painted realistic leaf colours in this background, using a range of greens mixed from Sap Green, Prussian Blue, Quinacridone Gold, Indigo and Lemon Yellow alongside Indian ink. I enjoyed letting the paint and ink flow and granulate, and dropped water into the drying paint to create backruns and mottled textures to represent crumpled leaves.

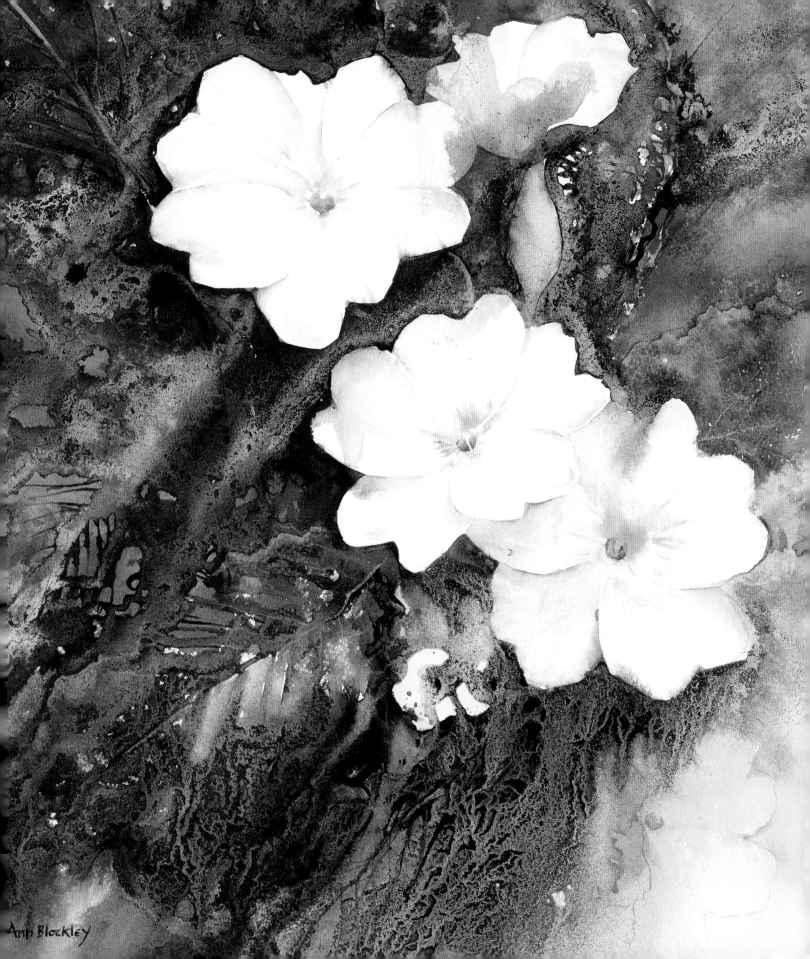

Ann Blockley

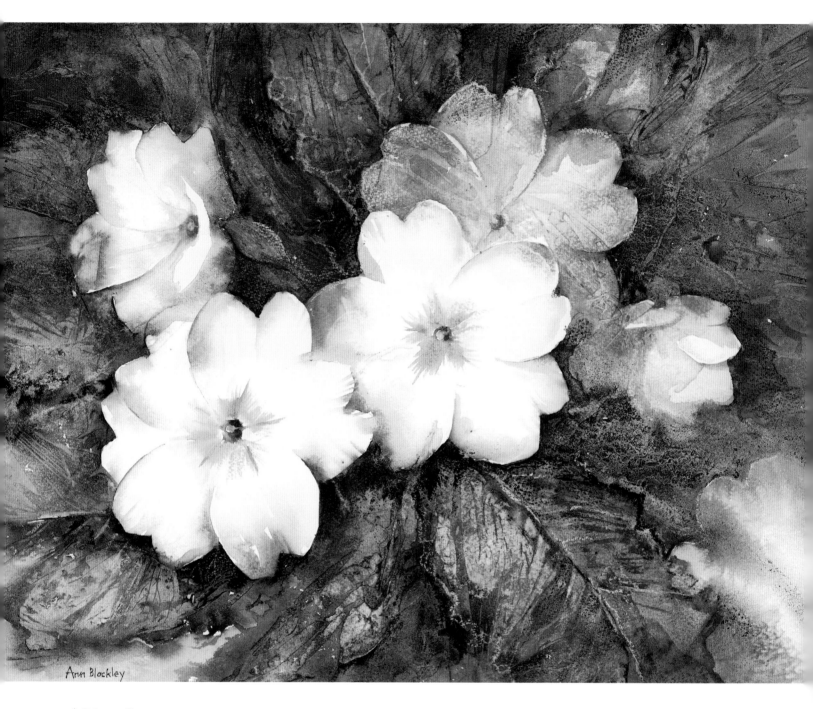

▲ Primrose Carpet

38 x 49cm (15 x 19¼in)

If I combine a number of techniques within a painting, I am careful to counterbalance this busyness by being selective with other choices in order to avoid an uncomfortable clash of ideas. Here I have used clingfilm, salt, acrylic ink, watercolour and crayons, but have kept to a harmonious colour scheme.

Playing with ideas

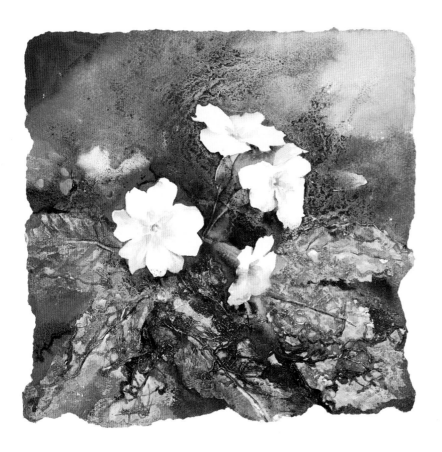

There are many different ways to solve a particular painting problem. I like to play with possibilities and experiment with ideas, either within a single picture or by completing a number of variations. One of my interests in painting primrose leaves is in finding effective methods for portraying their wrinkly textures. One way is simply to let the paint flow and create happy accidents. The granulations that happen when waterproof Indian ink is mixed with watercolour are also useful. The textures made when clingfilm is applied to a wet wash are very evocative of broken, creased leaves, especially when it is carefully placed in suitable directions to suggest veins. Table salt sprinkled into damp watercolour also develops an appropriate mottled appearance. Using oil pastel beneath or on top of a wash will give a rough, broken texture, especially on a Rough paper.

Altering the paper surface

Disturbing the paint in ways such as these creates interesting textures but, having painted primrose leaves several times using these techniques, I felt it was important to test some new ideas. I decided to see what effect would result from modifying the paper itself, before painting on it. Applying gesso to parts of the paper, using a brush or palette knife, creates uneven textures that can be intensified with the addition of collage. Layers of paint put on top of dry gesso settle into the ridges and furrows of texture in a way that suggests rather than replicates those in the primrose leaves.

▲ **Primrose Textures**
30 x 30cm (12 x 12in)
After this textured watercolour was completed I decided to modify it. I wanted to experiment with the picture edges, questioning whether a painting should always be a rectangle. I carefully tore around the painting's perimeter, emulating the organic patterns and ragged leaf shapes seen in the plant.

Backgrounds

Most of my flower paintings combine relatively detailed foreground flowers with a painterly background. I try to set a mood or convey an idea of the surroundings, the weather, the time of day, the season, or any story that I want to tell. Shapes and patterns in the background hint at and allude to other subjects, flowers, leaves or plant parts. The paintings tend to be based on reality, so that it is possible to imagine that the flowers are in, for example, a woodland, hedge or garden setting.

Choosing a theme

You could also experiment with other types of background using decorative or abstract elements, or place flowers in a still life with an indoor setting. All backgrounds should have some sort of theme. This may be a colour scheme or a pattern, or it may reflect some element within the flower itself, such as a particular marking, shape or habit. Backgrounds can provide harmony or contrast through colour, texture, pattern and so on. Whatever choice is made there should be an underlying reason for it.

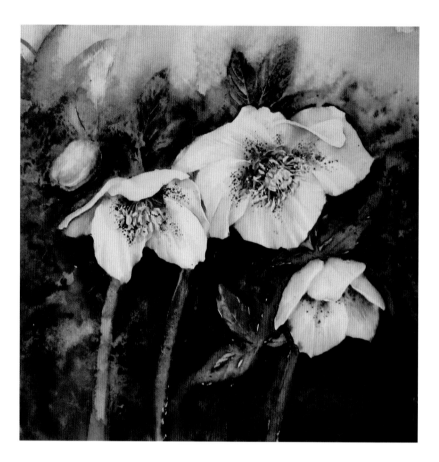

▲ **Hellebores 1**
26 x 28cm (10¼ x 11 in)
I took the idea for this background from the purple speckled patterns in the centre of the hellebores. I used the tip of a palette knife to splatter creamy dark paint into washes and added salt to it to create mottled textures.

▶ **Hellebores 2**
43 x 42cm (17 x 16½ in)
White hellebores appear when the ground is still relatively bare and their purity seems to shine out against the backdrop of earth and dark leaves. I used Indian ink with Sap Green, Permanent Magenta, Quinacridone Gold and Lemon Yellow watercolour to create an intense background that is a dramatic contrast to the white petals.

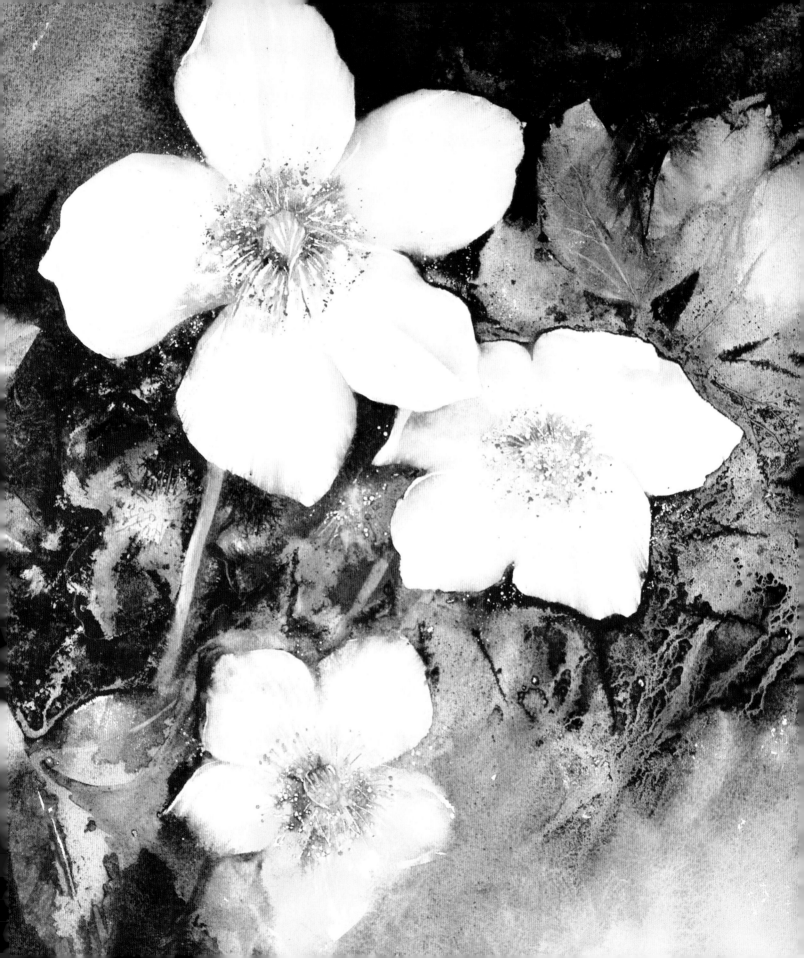

A fresh look at composition

In many flower paintings the purpose of composition is to draw the eye through points of interest towards a main focal point. Blooms are painted in various sizes and degrees of detail according to their importance in the painting. They are viewed from different angles and positioned to make an interesting pattern. Areas of colour, pattern or tone can be used to create visual pathways through the painting, or parts of the subject, such as a stem or the angle of a leaf or petal, can be used to point out a direction. In my compositions I have formed a habit of not placing subjects at the edges of the painting.

Trying a new approach

As this book is partly about breaking habits, I decided to try something different. By allowing hard edges and shapes to extend beyond the perimeters of a painting a larger number of negative shapes is created. These separate sections of background can be painted as individual areas. This is easier from a practical point of view but, more critically, seems to encourage a more abstract, patchwork effect. It is easy to change colour, technique or texture within each section and immediately more decorative and less naturalistic interpretations become possible. Whatever the style of a painting it is still important to lead the eye around the picture and create a pleasing composition, but when working in this way the concentration is largely on a two- rather than a three-dimensional space.

▲ **Detail**
I filled in some leaf shapes and the negative spaces between them with flat blue washes, leaving certain areas white. When these were almost dry I poured water over them. Some watercolour was rinsed away and redistributed in the unpainted shapes. Dark, smudgy edges of colour were left behind where the paint had dried the most. The result is an abstract patchwork of shapes.

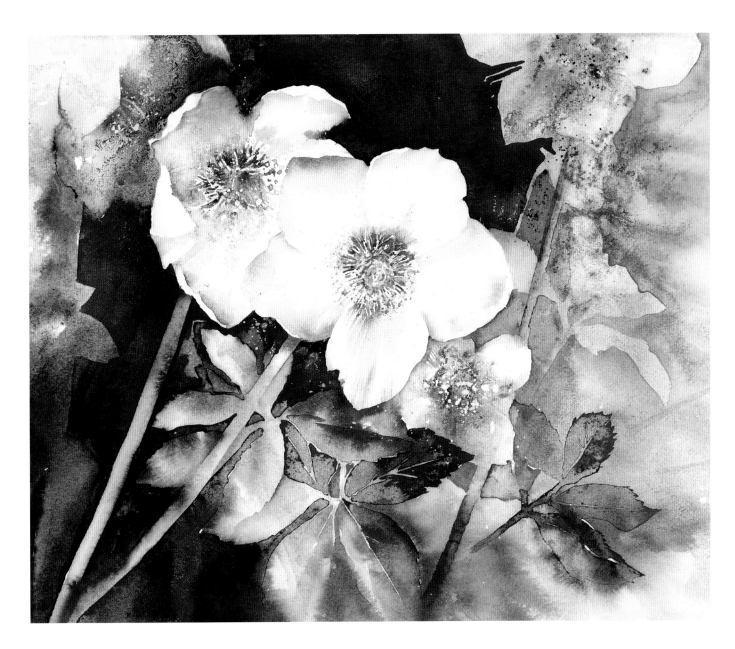

▲ **Hellebore Patterns**

32 x 37cm (12 ¹/₂ x 14¹/₂ in)

In order to compose a more abstract design than usual I straightened the curved stems so that they sliced the painting into sections and created diagonal pathways through it. The eye is led to the flowers that disappear out of the top but quickly returns to the larger flowers. I arranged the colours in a deliberately artificial pattern, with yellows in the side sections and complementary blues and purples to emphasize the central area.

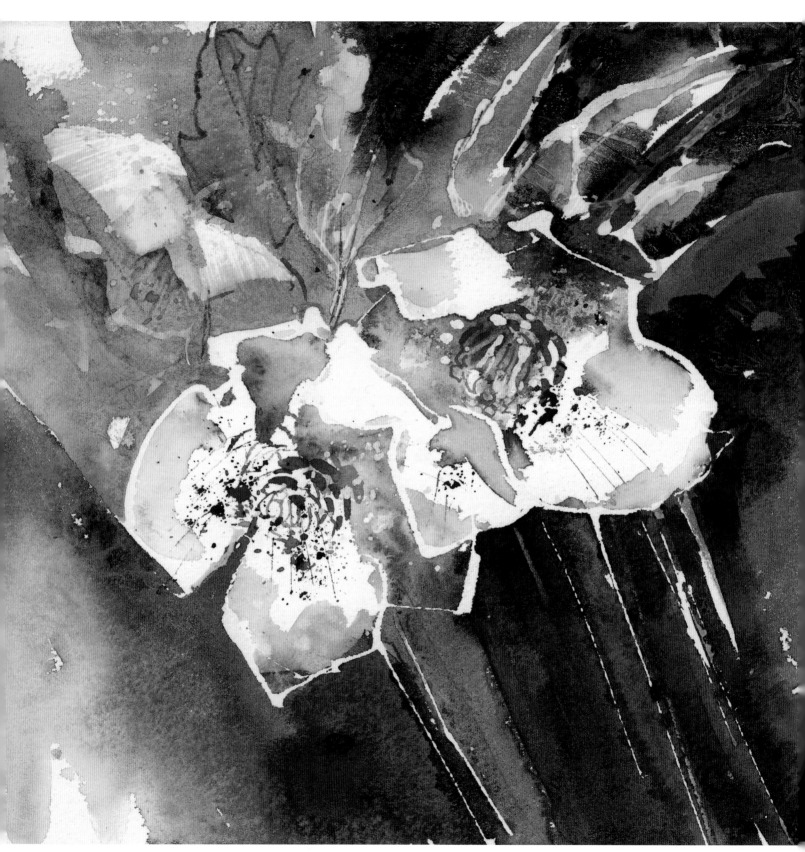

Creative mark-making

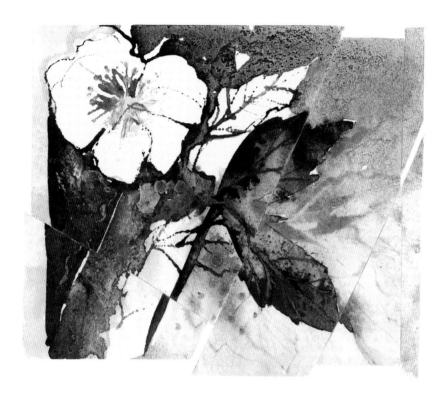

I seldom use a pencil to make a drawing. I prefer to make sketches with more painterly media as I find that I can work more loosely this way. When I make paint sketches I discover ways of representing subjects through expressive mark-making. I use a wide range of marks and lines that act, like shorthand, as a way of portraying something without the need to include every realistic detail.

Using various tools

Lines can be made by using any pointed tool, such as a stick or piece of bamboo, as if it were a pen. I sometimes drag pools of paint around the paper using the wrong end of my brush, which often creates a satisfying broken line. I also allow paint to dribble its own path. Lovely soft lines and dots can be made with a watercolour pencil drawn into wet paint, and pale lines can be scraped out of thick, damp paint using a scalpel. My favourite tool is the palette knife. I use the blade on its side to draw fine lines of paint or masking fluid and I use the flexible end to flick speckles of either medium.

◀ **Hellebore Impressions**

17 x 17cm (6 ½ x 6 ½ in)

This spontaneous impression has a strong linear quality. This is due to sketchy lines drawn around the flowers and leaves, using masking fluid applied with a pipette. The flower centres were made with chunky brushstrokes, lines drawn with a sharp stick and splatters from a palette knife. My priority was the colours and marks rather than a realistic finish.

▲ **Hellebore experiment**

I made a paint sketch by dragging paint into broken lines with the end of my brush. Then I abstracted the design by cutting the sketch into diagonals that echoed the shapes within it. I stuck the pieces onto some new paper, staggering the shapes to create fractured zigzag effects.

Challenging yellows

Daffodils present a yearly challenge with their distinctive form and vibrant yellow colour. During my year of flower painting I found myself uninterested in the realistic three-dimensional quality of the petals and trumpet but enjoying the zigzag triangles that the flowers made as an overall shape. My other main interest was to look at ways of describing the colour and presenting it differently. I decided to paint two pictures with contrasting personalities. One would conjure up the fresh liveliness of spring and another version would show the colour in a rich, moodier light.

Creating different moods

In *The Joys of Spring* I used Lemon Yellow, choosing this colour for its transparency. Many yellows have an opaque quality that would not be suitable for the fresh look that I wanted to develop. I used Indian Yellow for the darker trumpets. The background was made from stripes and washes of Winsor Violet and Viridian. I chose these colours as I had not used them for a long time and I wanted to experiment with some complementary colours in order to accentuate the painting's vibrancy.

In the second picture, *Mellow Yellows*, I chose Indian Yellow for the flowers, using it in dilute form for the petals and more strongly for the trumpet centres. This time I used Brown Madder and Sepia acrylic ink in the background, which made a strong tonal contrast with the subject but was also a harmonious colour combination.

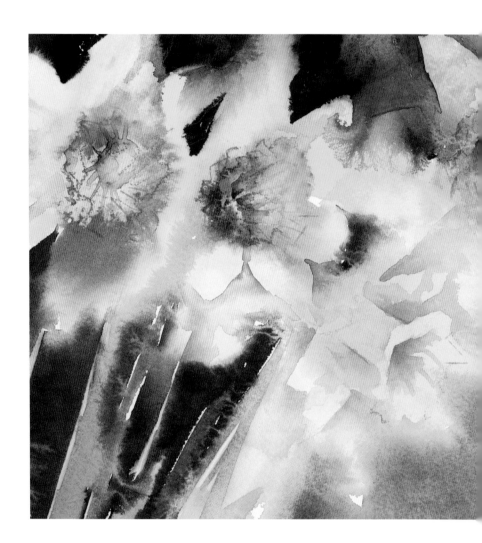

▲ **The Joys of Spring**
21 x 22cm (8¼ x 8½in)
The joyful exuberance of this painting is not only in the choice of colours but also in the way that they are allowed to flow freely from one area to the next with enthusiastic starbursts and exciting fusions.

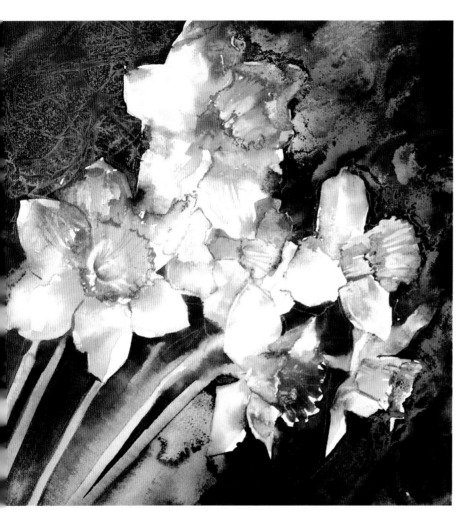

▲ **Mellow Yellows**

31 x 31 cm (12 ¹/₄ x 12 ¹/₄ in)

I kept the definition of the daffodils to a minimum, applying details only to the frilly
trumpet edges with soft red and brown Conté pencils. My interest was in the pattern
of the overlapping flowers rather than their individual shapes and parts. Within that
larger area I kept the petals loosely abstract.

▶ **Colour experiment** (above right)

Before I begin any painting I spend a long time experimenting with colour to find
the best combinations for the task I have set myself.

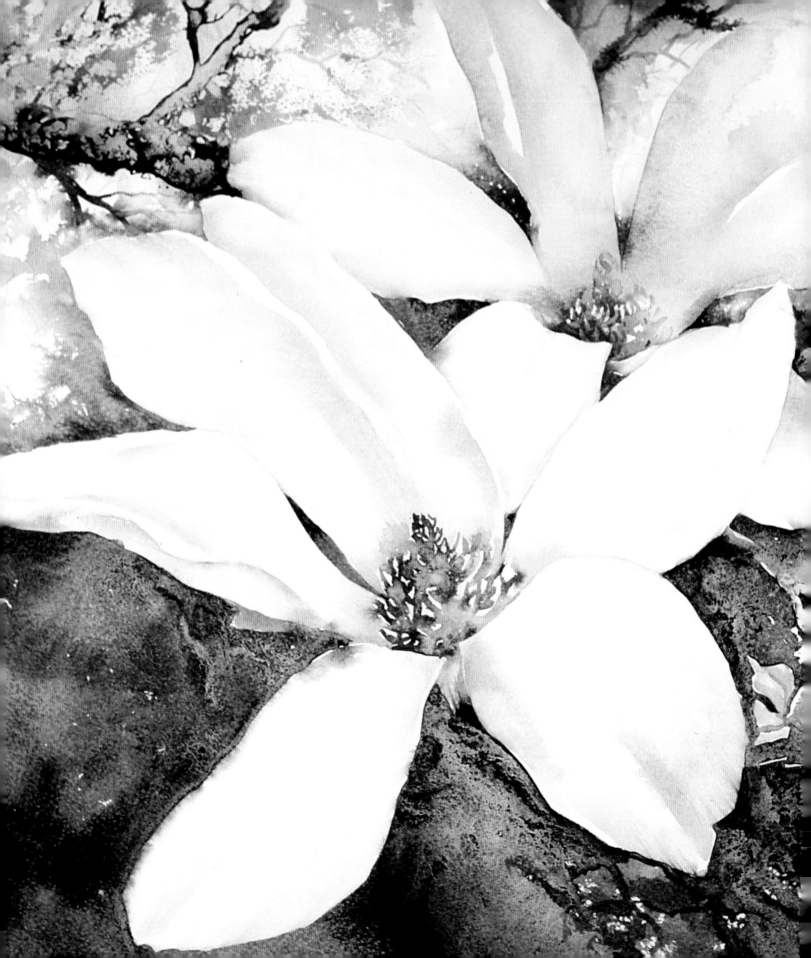

Using the white of the paper

Some subjects suggest all sorts of experimental methods and unusual uses of materials; others just cry out to be painted in a traditional way. When the white magnolias bloom on the tree outside my studio their dazzling blossoms instantly inspire me to pick up my watercolours. The fresh translucency of the medium is perfect for depicting the clean shadows of a white flower. The purity of their white shapes is best described by simply leaving areas of unpainted watercolour paper. In the painting shown here I used Saunders Waterford 'High White' Not. I find that this sparkling white paper creates a cleaner, more modern look than the original creamy-coloured surface. Bockingford and Whatman are alternative papers that are made in a bright white colour.

◀ **Magnolia**
40 x 53cm (15³/₄ x 21 in)

Working spontaneously

It is important to make preparatory sketches before beginning a finished painting. However, it can make a refreshing change to work directly from flowers without any initial planning and to try to switch off the censoring, critical part of your brain. The result is similar to colour doodles in that this sort of painting can be tremendously loose and spontaneous.

If I work without too much preliminary thought, it helps me to be more expressive in my mark-making. Curly petals take the form of effusive swirls. Neat flower centres become decorative dots. I find myself echoing shapes in the subject with the movements of my brush. It is sometimes useful to listen to music when working in this way as it can help to block out the intrusive thoughts that can inhibit spontaneity.

A loose approach

I find it particularly liberating to paint without any initial pencil drawing. Looking at the negative spaces between shapes can help you to draw accurately. Pencil lines encourage a tight approach as most of us were brainwashed as children into thinking we must not go over the lines. When there are no lines we can be as messy as we like. The colour in a stem can flow into a petal or shadow, and backgrounds are free to mingle with the subject. Keeping areas of white in the background as well as within the subject also helps a painting to remain fresh and unconstrained.

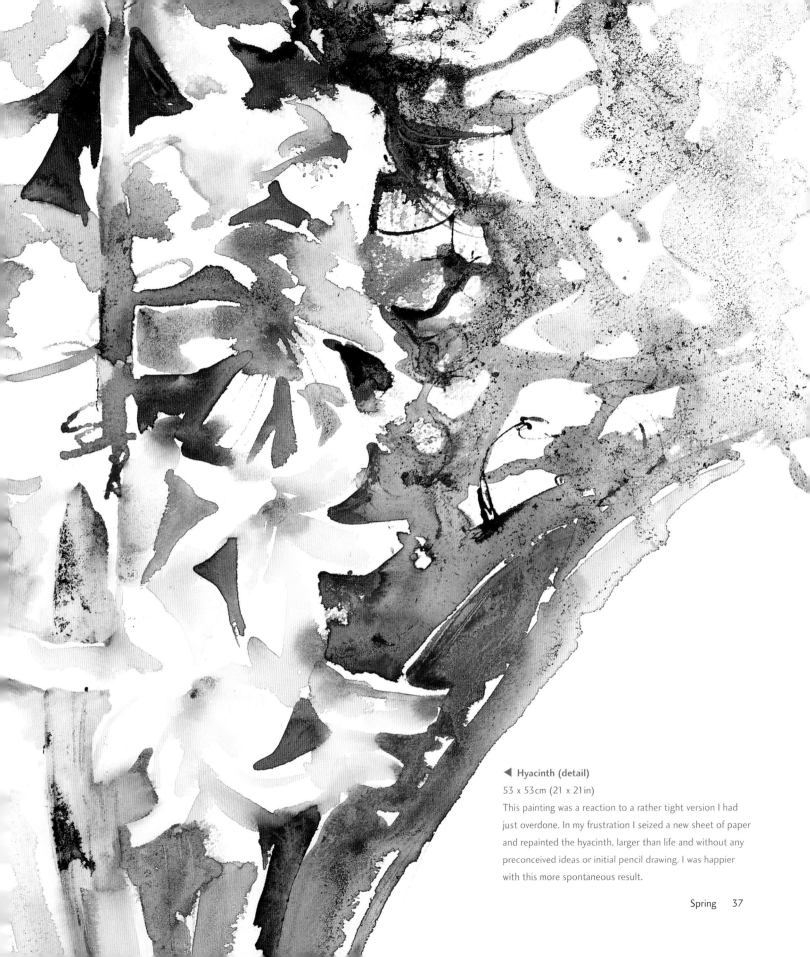

◀ **Hyacinth (detail)**
53 x 53cm (21 x 21in)
This painting was a reaction to a rather tight version I had
just overdone. In my frustration I seized a new sheet of paper
and repainted the hyacinth, larger than life and without any
preconceived ideas or initial pencil drawing. I was happier
with this more spontaneous result.

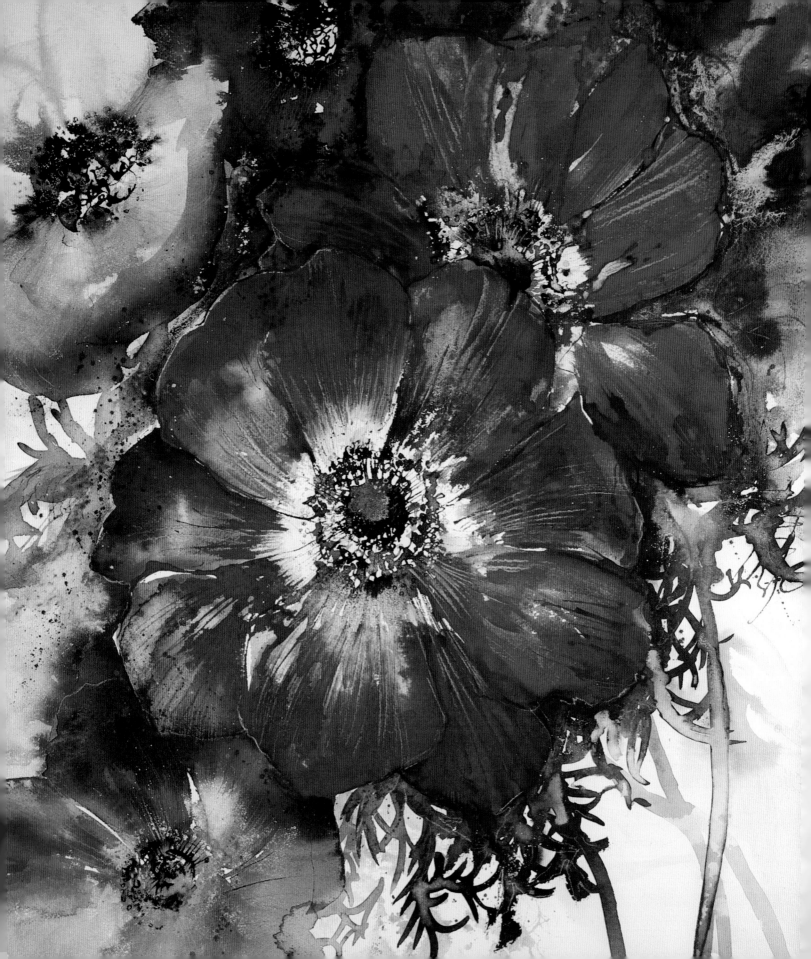

Exploring watercolour

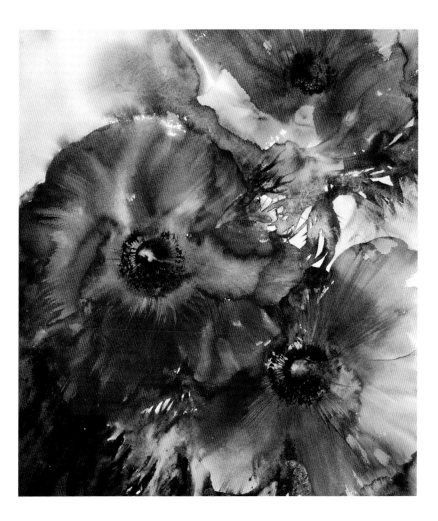

Watercolour can be a gloriously expressive medium when employed to its full potential. It can take on a number of personalities when used in different ways and you can paint with it in tight detail or very loosely. Judging the consistency and wetness of pigment and surface is crucial to watercolour techniques. When the paint is used thickly, with the minimum of water, it can be rich and opaque. Creamy watercolour can be scraped out with a blade to reveal paler marks. Dry pigment can be dragged across the paper to create broken brushwork, whereas dilute paint tends to flow romantically into juicy, translucent wet-into-wet washes.

Creating expressive washes

The traditional rule of watercolour is that you do not return to a wash until it is dry as this will disturb it. The modern approach, however, is that backruns or blooms add expression and variety to the wash. I deliberately add water to drying washes to produce marks that can represent edges of petals or leaves, a contour, or a change of light. Sometimes I paint on paper that has been soaked with water to create a soft, floating style. I enjoy allowing the paint to go where it wants and I take control only later by adding further layers.

There is nothing ground-breaking about these thoughts. However, it is so vital to understand the qualities of a medium before branching off in new directions that I constantly remind myself of these basic facts.

◀ **Anemones 1**
63 x 54cm (25 x 21¼in)
I used both creamy and dilute watercolour in this painting to vary the translucency of the flowers. I scraped fine pale lines out of some of the petals using a scalpel. When the first washes were dry I splashed spots of paint into them by vigorously shaking my laden brush.

▲ **Anemones 2**
75 x 56cm (29½ x 22in)
This large watercolour was painted on wet paper to create a soft-edged quality with lots of expressive backruns. I painted it standing up to enable me to work in a more physical fashion with free arm movements.

Experimenting with shapes

When flowers are viewed from all angles it is surprising what variety of forms they produce. Anemone stems make particularly pleasing patterns as they bend and meander, and I enjoy finding ways to represent this sinuous quality. Sometimes I simply allow paint to run down the paper in random lines to represent their stems. The frilly, leaf-like collars also make fascinating, curly tendril shapes that can be re-created with quick swirls of the brush or even paint scribbles. Occasionally I build flower centres out of small circles; this may not be a true representation but it is a satisfying shorthand. One way of including some shapes within the flowers is to apply clingfilm to a wet wash, which creates an abstract impression of crumpled petals.

Using a white background

Having painted many flowers with colourful backgrounds, I have become interested in the idea of displaying them on plain white paper. Without any distractions behind these bold and graphic flowers the emphasis is on their shapes and the marks contained within them. After painting some anemones onto white paper I decided to add an extra element of interest. I tore around the painted shapes, leaving rims of white, and stuck them back down on another sheet of paper. Any bits of watercolour that seemed superfluous could be ripped away and new areas added if necessary. Making collages out of watercolour has enormous potential for a whole range of experiments!

◀ **Potential collage piece**
Pieces like these, cut out of a flower painting, can be added to a collage to make a quirky abstract picture.

▶ **Anemone Collage**
51 x 46cm (20 x 18in)
Making a collage on a white ground creates a crisp, clean look, but there are endless possibilities for working with a variety of paper types in different colours or shades of white.

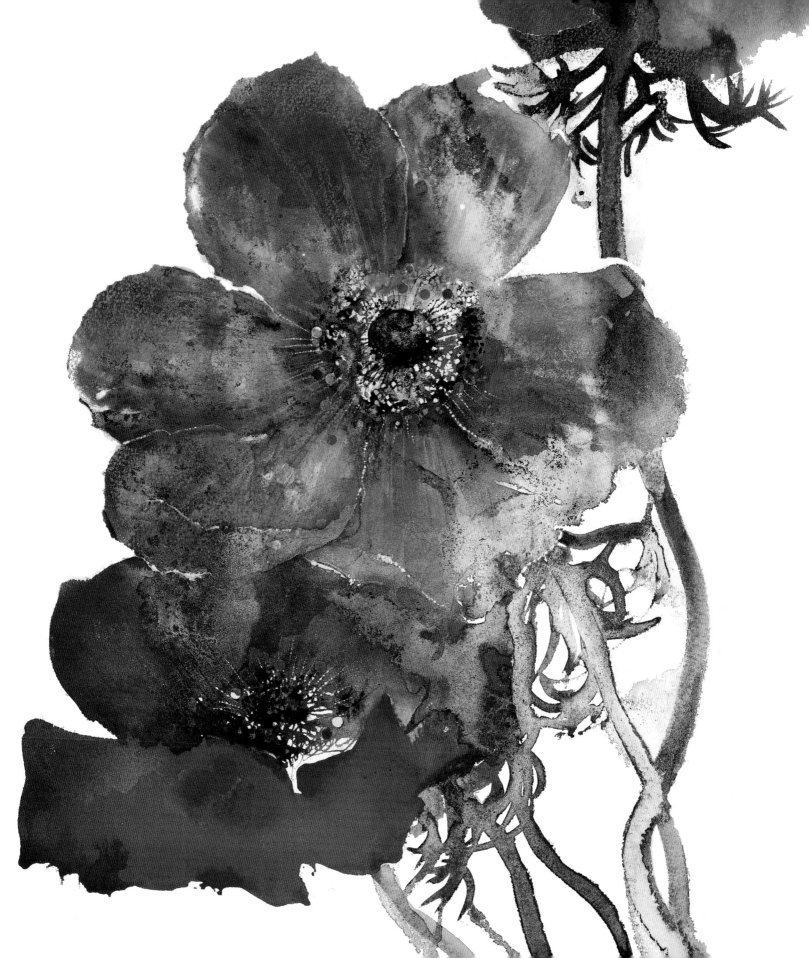

Capturing the essence

My idea of capturing the essence of a flower is to describe its character with impressionistic watercolour. I decide which aspects of the flower are important and emphasize those traits without using detail. An abstract painting could distil the essence of a flower into a few lines or blocks of colour, like a sort of logo or emblem. Although I am interested in making those sorts of experiments, this book is more about semi-abstract interpretations where the subject is recognizable but retains an air of mystery and still leaves food for thought.

Identifying key features

Every flower has many characteristics and it is up to the artist to decide which particular features to make most prominent. There may be several significant sides to the flower's personality. You have to be selective, or stress different qualities in a series of interpretations rather than combining an excess of ideas within one painting.

To me, the archetypal iris is the statuesque purple variety, with its rich velvet petals and unique shape. The heraldic emblem of a fleur-de-lis is based on an iris or lily and it would be interesting to reflect this in a graphic, formal painting. I sometimes bring out this royal quality through intense colour and even embellish my iris paintings with sequins or gold ink. Another fascinating feature of the iris is the white markings at the base of the petals. I like to contrast these hard-edged patterns with floating background washes. Emphasizing characteristics and creating an appropriate mood both help to capture the essence of your subject.

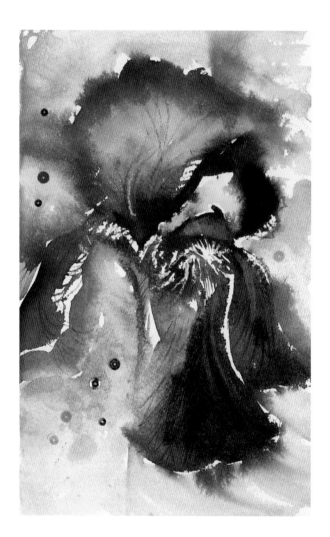

▲ **Iris Shimmer**
24 x 15cm (9¹/₂ x 6in)
I gave this iris a celebratory glamour with shimmering iridescent medium brushed into the background, and added sequins.

▶ **Royal Iris**
37 x 37cm (14¹/₂ x 14¹/₂in)
I expressed this iris's grandeur by painting it larger than life. I captured the velvety petals by using creamy paint and blurred edges.

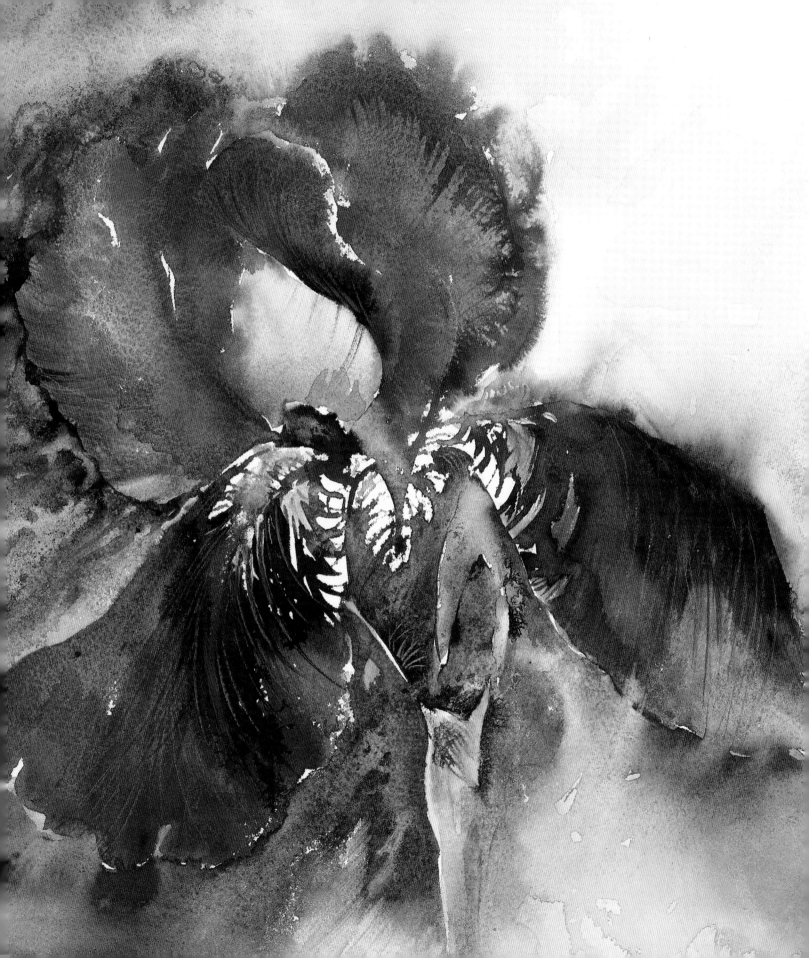

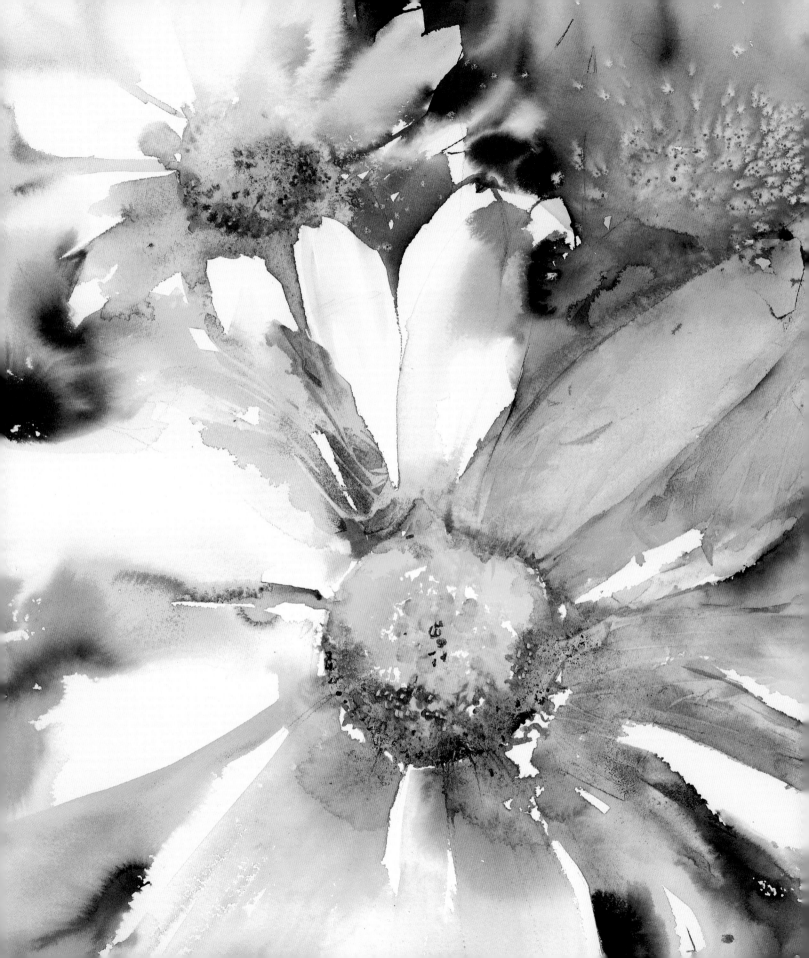

Choosing a format

The format of a painting hugely affects its impact and character. Because traditional paintings are generally designed within a standard rectangle I often find myself composing my pictures in alternative shapes. Squares have a modern feel and long, thin formats are quirky and unusual.

Although it is obvious to place a tall plant within a similar-shaped frame, it can be fun to experiment with all the different options. This exercise in composition helps to shift complacent, lazy habits. Allowing shapes to spill over the edges of the picture area is one design solution; another would be to position flower heads mainly at the top or bottom, leaving plenty of space for stems or 'sky'. Fitting two flowers into a square format is a challenge, especially if they are of equal size, as however you position them they will always be in a row. I usually find that a diagonal composition works best, with one flower dominating the other in style or size.

◀ **Fresh as a Daisy (detail)**
37 x 34cm (14¹/₂ x 13¹/₂in)
I let the main daisy burst out of the sides of this squarish picture. It does not feel cramped because I retained plenty of white paper to keep the painting fresh. The soft edge values also contribute to the sense of freedom.

▶ **Daisy, Daisy**
30 x 10cm (12 x 4in)
I would not usually recommend having two similar-sized flowers balanced on top of each other, but it is fun to defy conventional composition rules occasionally. It works here because of the way that the daisies are cropped at the edge. The abstract vertical lines at the bottom help to balance the design.

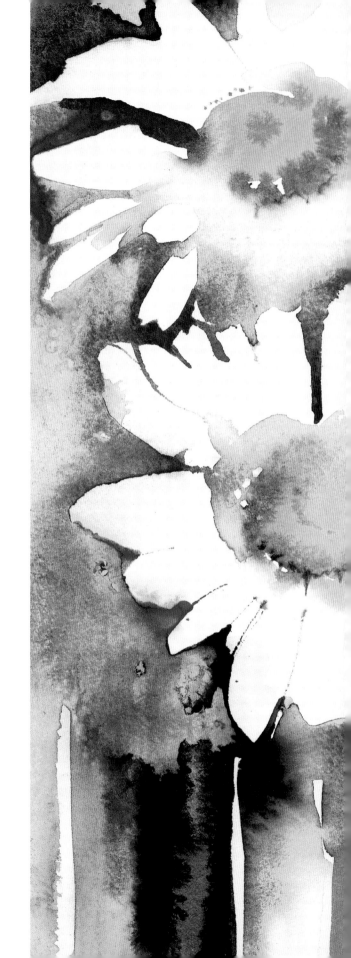

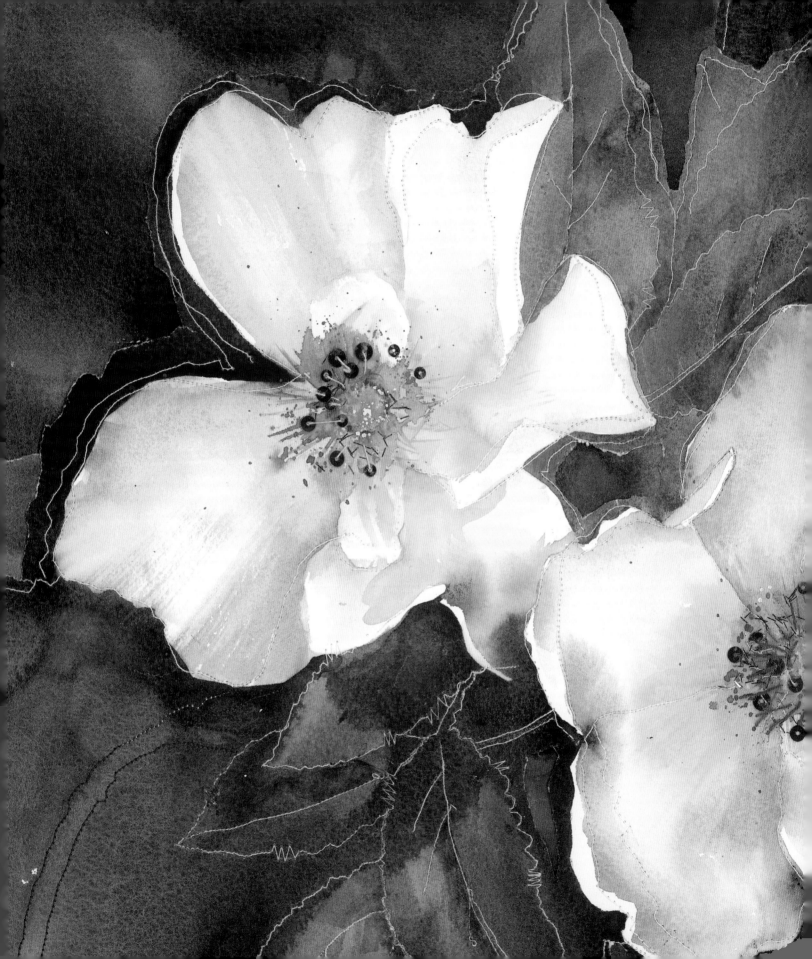

Summer

The incredible variety and profusion of summer flowers mean that it is more important than ever to be selective in your choice of subject. Developing themes and exploring new ideas and methods will help you to find your own personal style. You need to find ways to interpret the array of subjects with originality and flair to make your paintings stand out from the crowd. Summer is the ideal time to continue following your own creative paths by having fun with experimental painting.

◀ **Rose Appliqué**
38 x 44cm (15 x 17¼in)

Exploring a theme

As flowers appear through the seasons, I enjoy painting them repeatedly in different ways. I like to have a theme, such as a flower type to explore. By painting a subject many times I increase my understanding of it at both a visual and an emotional level.

Using different colours and methods

When the hollyhocks appeared outside my studio I started a series of explorations, which are shown on the next few pages. I began by painting them in the naturalistic colours demonstrated here. When I tired of the sweet sugar-almond tints I changed them into white hollyhocks, giving them imaginary background colours to convey a more sombre mood. Purples, browns and turquoises created an impression of twilight mystery. As the hollyhocks continued to bloom, I furthered my painting quest to find just the right mode of expression. By the end of the series I was using different methods, but had returned to the traditional hollyhock pinks, although I used stronger pigment to counteract any prettiness.

In all my versions I played with composition and colour, and used a variety of methods to create leaves, petals and the characteristic stems with their round knobbles of buds. As I became relaxed and familiar with the subject, the interpretations became more experimental.

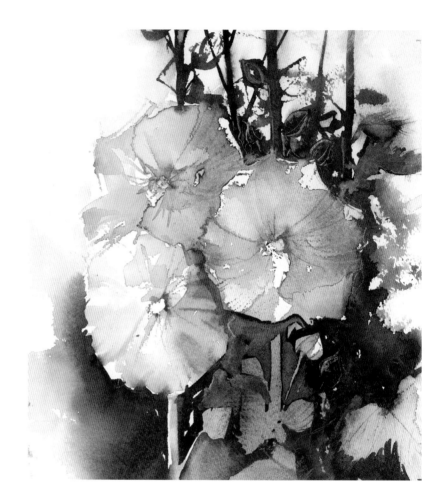

▲ **Hollyhocks 1**

21 x 19cm (8¼ x 7½in)

In this version I dropped water into the drying petal washes to make backruns and ragged edges. I painted the stems and buds at the top using thick paint, defining some buds by scraping out pigment with a scalpel and moving the paint around elsewhere with the end of my brush.

▶ **Hollyhocks 2**

38 x 21cm (15 x 8¼in)

Sugar-almond colours were painted onto these flowers using separate small washes. When these were almost dry I poured water over some of the colour to leave hard-edged washes that made an unusual interpretation of the crumpled petals.

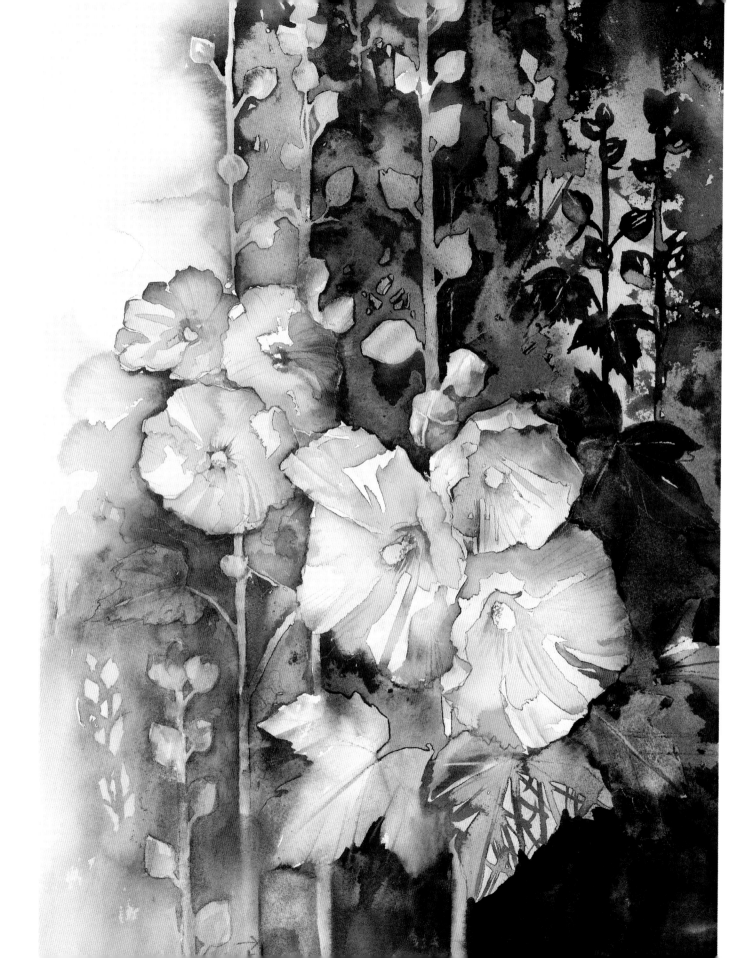

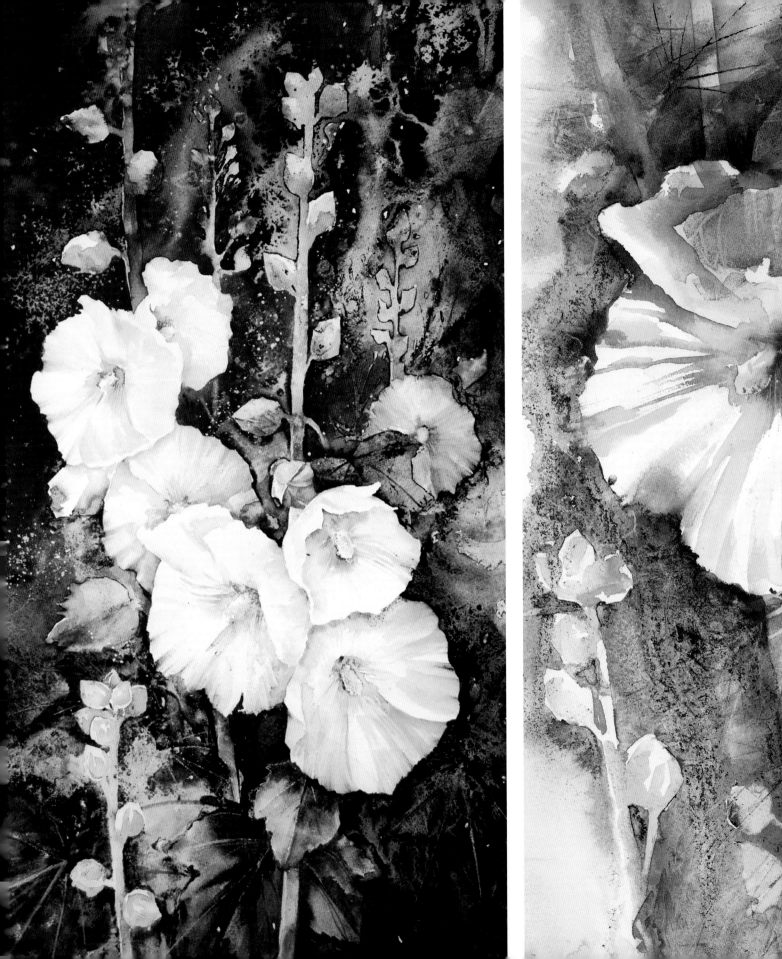

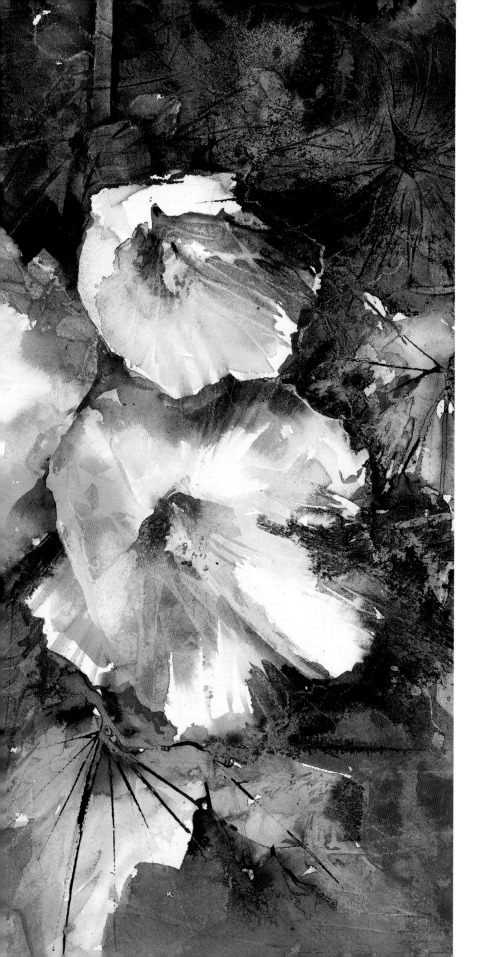

◀◀ Hollyhocks 3

39 x 30cm (15½ x 12in)

I evoked an air of mystery with rich, dark colours and used
salt in the background. The textures created a movement and
visual buzz to remind me of the many tiny insects flitting and
humming in and around the flowers.

◀ Hollyhocks 4

39 x 39cm (15½ x 15½in)

This version is based on the same flowers as those in
Hollyhock 3, featuring only the front three florets. I used
clingfilm to break the petals into crumples and indicated the
veins on the leaves by printing lines with the edge of some
thick watercolour paper.

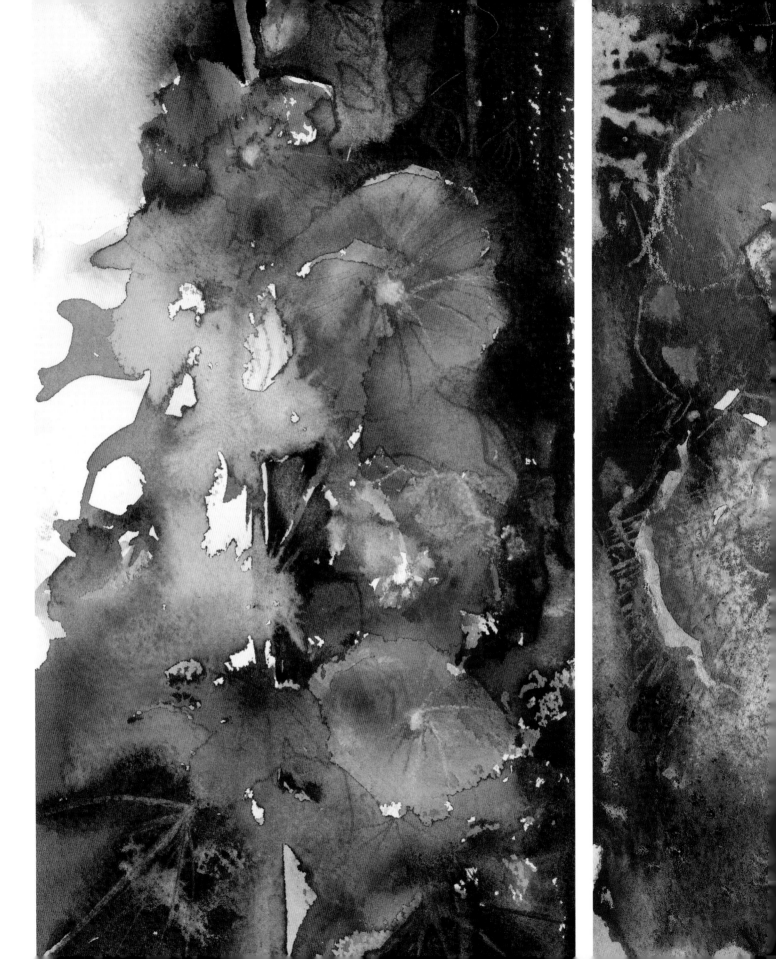

Being original

Finding an original style is difficult as everything seems to have been done before! Sometimes you have to try lots of different ideas to find one that 'fits'. It is a bit like trying on clothes in a shop. You usually know when something feels uncomfortable and does not suit you, and when something feels right it gives you a tremendous boost. The only way to discover your personal painting style, with its own unique combination of colours, methods or ways of looking at a subject, is to keep practising and experimenting, perhaps using a theme as I have done with my series of hollyhocks.

◀◀ **Hollyhocks 5**

25 x 13cm (10 x 5in)

After painting hollyhocks in different colour schemes I reverted to variations of pink, but threw in some purple to spice things up. I allowed all the colours to merge in a glorious watercolour medley that is a truly romantic interpretation of this cottage-garden flower.

◀ **Hollyhocks 6**

19 x 12cm (7½ x 4¾in)

Having painted some conventional interpretations of hollyhocks, I decided to explore further by working on a collaged surface. I tore paper into rough petal shapes and stuck them onto a bigger piece. I then painted on top. This sketchy experiment gave me lots of ideas for future work.

Expressive leaves

Leaves are an integral part of the flower painter's repertoire. They may not often take a starring role, but they provide great opportunities for playing with composition and for counterbalancing or echoing qualities in the actual flower. Rather than always picking out individual leaves, look for the patterns made by a mass of foliage and the gaps shining through. If the latter choice is made, the shapes can be arranged so that they point a way through the painting.

Choosing techniques

The type of leaf will usually dictate the technique to be used. A sharp, serrated rose leaf, for example, may benefit from crisp edges. A favourite method of mine is to paint leaves in dark, creamy watercolour and then wash some of the paint away with water when it is nearly dry. This can create hard edges and cloudy patches of light and shade such as those in my leaf experiment (opposite page, bottom). Try bringing negative leaf shapes out of a dry background wash or painting soft suggestions in a wet-into-wet style. Experiment with using different-shaped brushes to make a variety of marks. I particularly like using a flat brush to create slightly geometric leaves. The main aim is to paint expressive leaves with as much attention as you would lavish on the flowers themselves.

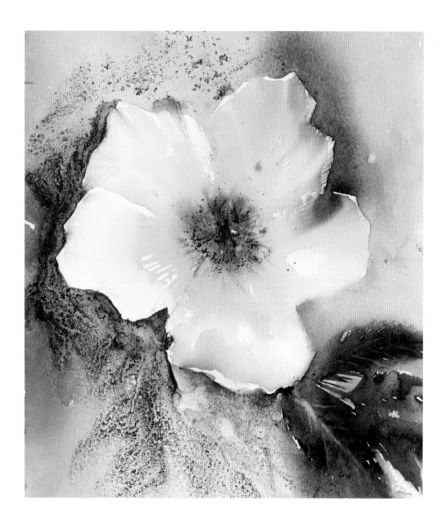

▲ **Rose Glow**

39 x 29.5cm (15 ½ x 11 ¾ in)

These leaves were painted when the background wash was both damp and dry in different places. The result is an expressive combination of hard and soft edges. Suggestions of veins were lifted out of the drying green pigment using the thin edge of a flat brush.

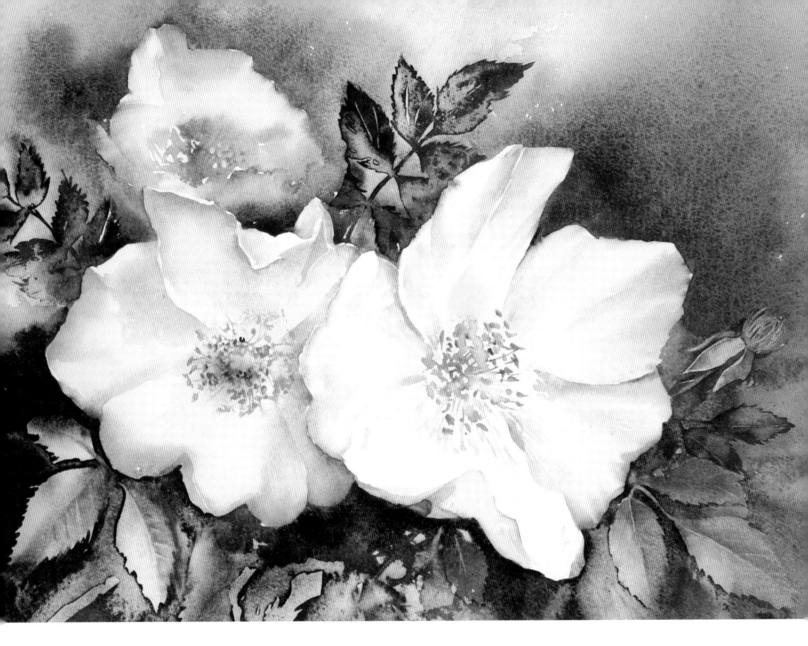

▲ **Rose**

35 x 42cm (13¾ x 16½ in)

In a subject such as a rose, which can be rather chocolate-box in style, I try to balance the prettiness by using strong contrasts and hard edges. The leaf patterns in the lower left-hand corner are almost abstract, with their broken snippets and suggestions of leaf and stem shapes.

▶ **Leaf experiment**

When adding leaves to a background it is a good idea to experiment with different methods first on scraps of paper. You can then hold these over the picture to try out different positions.

Interpreting your subject

There is no right or wrong way to interpret a
subject. It is a matter of personal taste. I am always
looking to find new ways of expressing myself, but
I realize that many people will prefer my more
conventional style. As an artist, I think it is
important to disregard what other people think and
follow your own inclinations. If you try to please
others or repeat yourself too often, your paintings
can become soulless. I try to rethink my paintings
before they reach this stage through a continual
process of new interpretations.

Varying your style

I have often painted foxgloves as part of a
traditional scene in a representational fashion.
A typical example would be placed within a
background suggesting foliage and dappled light.
'Wild and Wicked Foxglove' is an updated, more
idiosyncratic version with flower and background
merging into abstract patterns. Texture was added
by mixing paint with granulation medium and the
magenta speckles of the foxglove bells were flicked
on with an old toothbrush. The acid colours and
dark markings were planned to lend an air of evil
and mystery, as foxgloves are highly poisonous
and must surely be the chief ingredient for a
witch's cauldron!

▶ Wild and Wicked Foxglove (detail shown far right)
47 x 19cm (18 1/2 x 7 1/2 in)

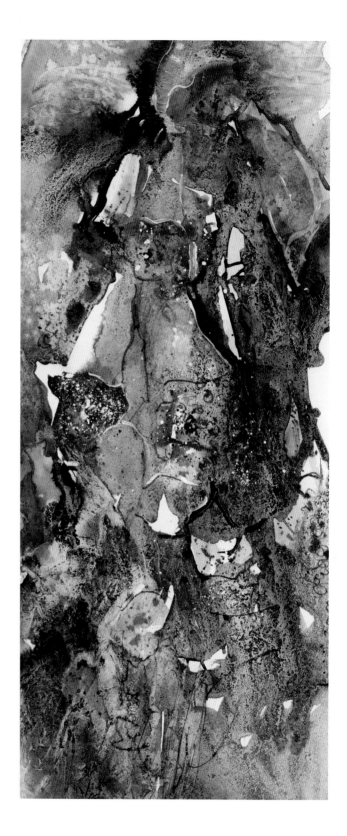

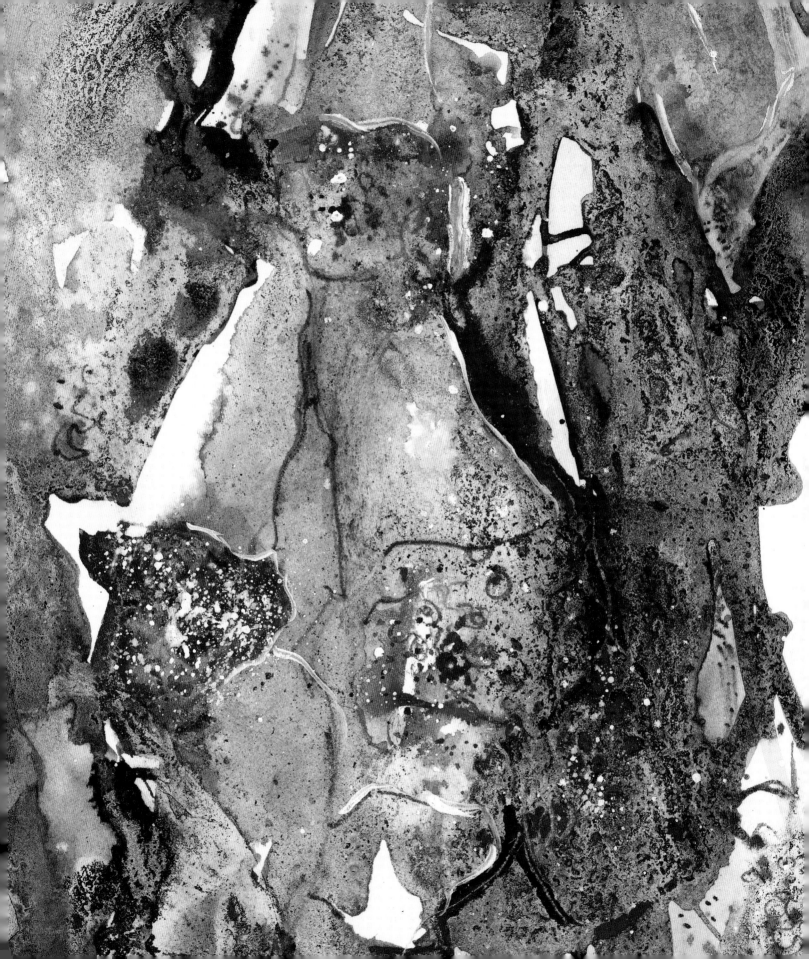

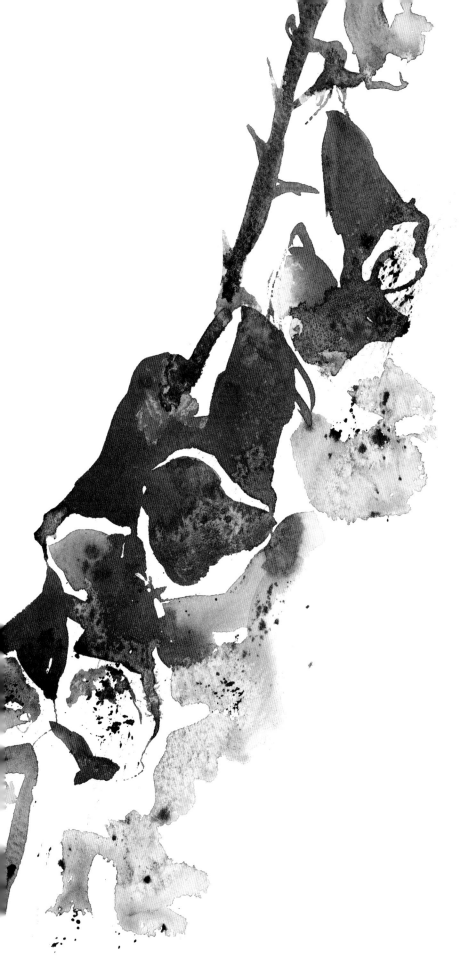

Avoiding the literal

An artist's creative 'handwriting' is very often defined by the choice of marks and brushstrokes. These form a personal painting shorthand and are an abbreviated or symbolic mode of expression. For example, the edge of some cardboard dipped into paint and printed onto paper might represent a stalk. The end of a watercolour pencil shaved into a wet wash creates speckles that could suggest a flower centre. Dots and dashes made with some wax crayon may be all that is needed to portray a stamen. The possibilities are endless and the way that you combine such marks is what makes your paintings unique.

Expressive interpretations

In both foxglove drawings, the palest areas were left as white paper so that jigsaw patchworks of pink and white emerged. In one foxglove I made extra shapes with my brush in the background to echo those in the flowers. In another version I dragged pools of paint into scribbles that loosely expressed the outline of the flower, using the wrong end of my brush. The irregular mottled blotches were translated by adding salt to the watercolour and by flicking dark colour with my palette knife when the paper was both damp and dry to vary the effect.

◀ **Foxglove paint sketches**
In these interpretations of foxgloves I looked for ways to represent the shapes and markings of the flower that were not too literal. My main interest was not in the three-dimensional forms of the foxglove bells or their individual shapes but in their curving, elongated profile and the abstract patterns made by the interlocking and overlapping bells.

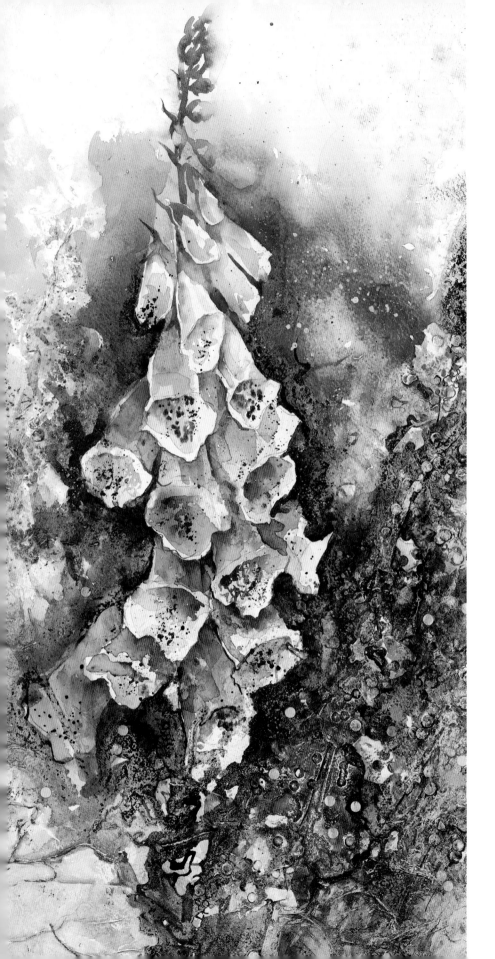

Starting with collage

When I began to experiment with collage I found that it was a great way of starting to release myself from the confines of being too realistic. The habit of seeing subjects exactly as they are and painting them like a photograph is an extremely difficult one to shake and I decided to tackle this a bit at a time.

Combining watercolour with collage

Many people work on a base made entirely from collage. This can produce fantastic results when working with media that have plenty of covering power, such as acrylics or gouache. If watercolour is used, its translucency means that the collage can easily dominate any subsequent paintwork and it therefore needs to be included sensitively. My first experiments used only small elements of collage. The added ingredients gave an abstract flavour to an otherwise representational style.

In one of my first experiments, *Foxglove Fantasia*, I used only bits of collage on a paper base, which meant that the watercolour was still able to flow and I could continue to enjoy its particular qualities. I used PVA glue to stick on collage that included torn and cut pieces of watercolour paper, tissue, and brown sand covered and sealed with gesso. I rubbed oil pastel over the raised lines created by the crumpled tissue paper. These marks suggested the foxglove stamens that are left behind after the bells have fallen off. The speckled texture of the sand sprinkled into the background echoed that in the mottled flowers.

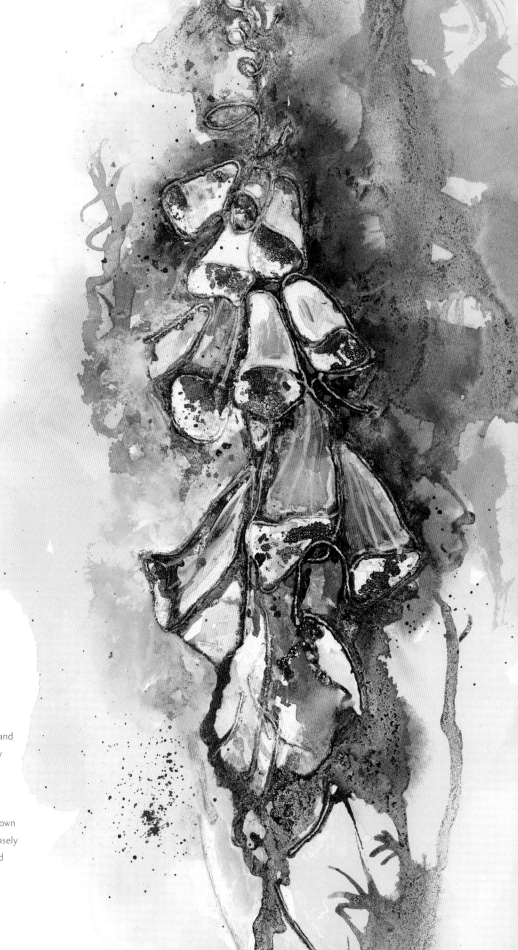

◀ **Foxglove Fantasia**

49 x 26cm (19¼ x 10¼in)

I used a hole punch to make little circles in some paper and stuck both the circles and the perforated paper onto my background to form an impressionistic foxglove.

▶ **Foxglove Patterns**

This is a detail from a painting that I made by sticking down string to 'draw' with. The resulting shapes were quite loosely based on those of a foxglove. Sand stuck on and painted roughly describes the textures in the bells.

Choosing your subject

A subject is usually chosen because a particular visual quality inspires you to paint it. This can be anything at all and does not have to be something that is especially beautiful or complex to qualify. It is the way that you interpret the subject that can transform the most mundane weed into a celebrity! Sometimes a little negative voice in your head censors every creative thought you have and kills it before it can blossom, but try to resist this and never impose limits on anything that you feel you would like to paint. There is no magic formula or rule as to what makes a good subject as it is a highly personal decision.

Personal associations

I often choose subjects that have a particular meaning to me or a special memory associated with them. For example, my father once commented on how difficult it would be to paint a dandelion clock, with its complex, fragile, transparent structure. This single observation made me determined to meet the challenge. Decades later, I have painted them so often that dandelion clocks have almost become my signature subject. In each new interpretation I experiment with slightly different methods, colours or backgrounds in order to make a fresh statement.

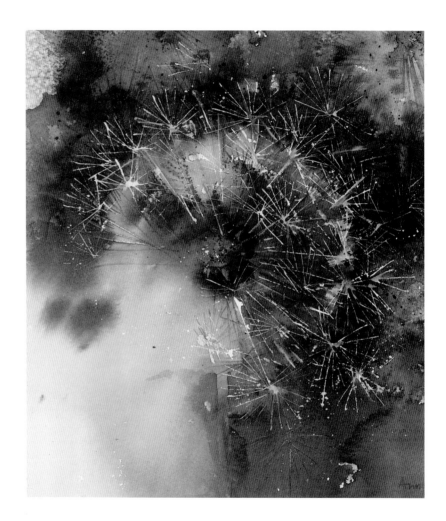

▲ **Time Flies**
22 x 22cm (8½ x 8½in)
The different stages of a dandelion clock as the seeds blow away present different painting challenges. This loose, open clock was created by allowing the background washes to merge into the seed head with no firm boundaries.

▶ **As Time Goes By**
28 x 17cm (11 x 6½in)
This interpretation is as much about the textured background as the clock itself and the way that the granulated pigments almost erode the seed-head shape. Speckles of acrylic ink were flicked with a palette knife into the centre to add a visual link between the subject and its setting.

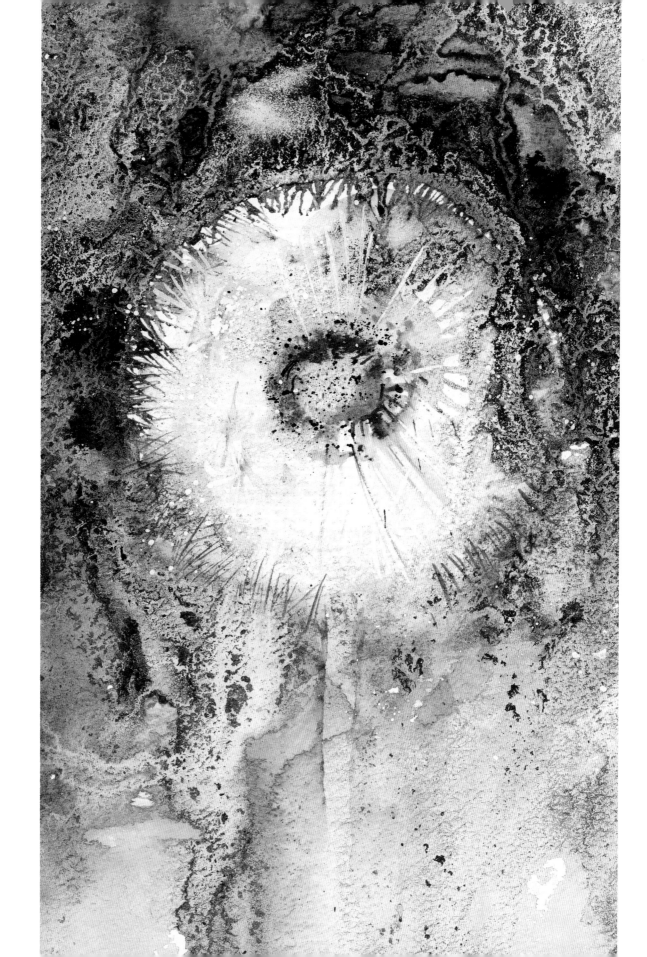

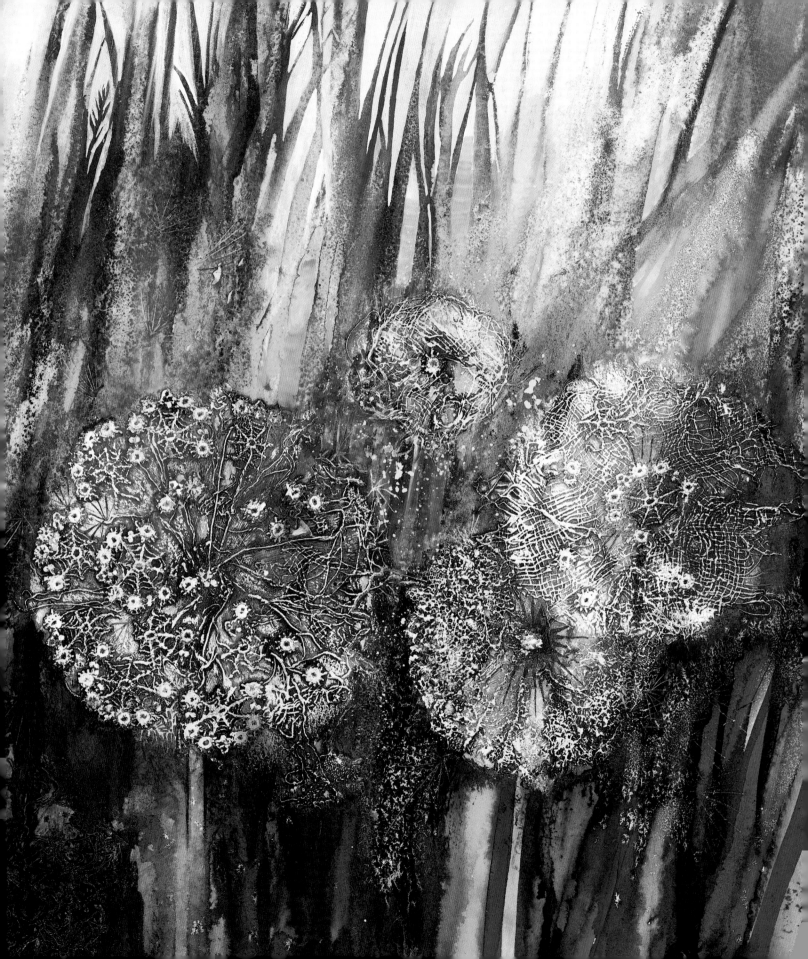

Developing ideas

When I first choose a flower to paint I usually begin working in the ways that seem most natural and easy to me, with fairly accurately observed representations. After I have painted a subject a few times I develop any ideas that have arisen from these explorations. At this stage I am aware of the realistic botanical facts but try not to be overly influenced by them, preferring to interpret with my imagination and develop a more personal vision.

Looking for patterns and motifs

Through my observations of dandelion clocks I am familiar with the way that the three-dimensional globe is made up of a constellation of delicate thistledown attached to hundreds of tiny seeds. These all gather at the centre around the top of a stalk. I have noticed the way that the fragile stars overlap and create networks of pale lines. As my ideas developed, I decided to summarize these factual observations by using patterns and motifs that reminded me of the subject without being too exact or specific. In these decorative experiments I repeatedly used the circular motif of the clock. I also included the idea of broken line work, based on the structure of the clock, which began by being a complex formal arrangement and then became increasingly random, as the seeds were blown away.

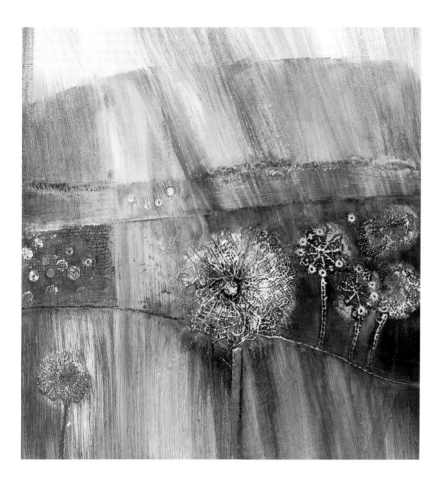

◀ **Meadow Clocks**
41.5 x 42cm (16¹/₄ x 16¹/₂in)
These stylized clocks have an air of fantasy. I used collage motifs to build a base and then painted on top. I added grasses behind, positioning them from a mouse-eye view to add to the storyline.

▲ **Fields of Clocks**
22 x 22cm (8¹/₂ x 8¹/₂in)
I divided this painting into sections to create a pattern suggestive of fields. I did not attempt to suggest distance and the clocks are a collection of two-dimensional motifs. The idea was to make a decorative design based on actual observations that have been distilled into almost symbolic forms.

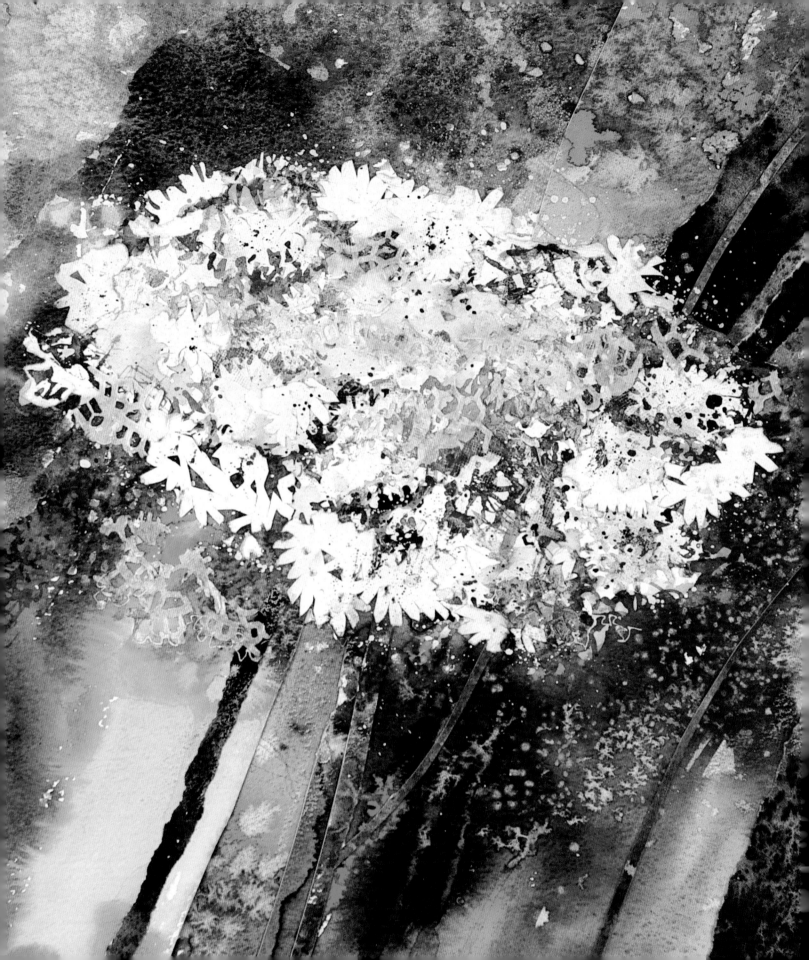

Moving on

I have used watercolour many times to portray summer hogweed, blocking out the most defined petals with masking fluid but adding fine speckles of extra masking fluid with a toothbrush to loosen up the effect. I have also added salt to hogweed backgrounds, as table salt creates fine textures and coarser rock salt develops into starry petal shapes very reminiscent of this lacy flower. I now wanted to move on to alternative methods, combining some of my earlier modes of expression with new ideas.

Thinking creatively

In *Summer Hogweed* I felt too impatient to use masking fluid. I wanted, initially, to create a more spontaneous interpretation so I used broken brushwork to represent the lacy petal textures. I added salt in my usual way and then decided how to proceed with the painting while it was drying. Other than being looser than ever, so far it was not radically different from previous interpretations and I felt that the impressionistic petals did not have enough definition or impact. I decided to tear the picture up! This was a considered decision and I did it thoughtfully, planning to create a diagonal composition with my torn shapes. I reassembled the pieces into a collage and then added petal-like shapes, cut out of white paper. These were quite crudely cut and slightly geometric as I did not want the painting to look too realistic.

◀ **Summer Hogweed**
30 x 25cm (12 x 10in)
Bits of paper doily added to the collage of torn watercolour pieces and cut-out paper shapes increase the painting's decorative quality.

▲ **Summer Hogweed 2**
This is a detail from another unfinished version of **Summer Hogweed**, demonstrating the watercolour textures in their first stage.

Telling a story

I like my flower paintings to tell a story, but by this I do not mean that I want them to be illustrations. The most vital part of the painting process for me is the paint itself, with its marks and textures, colours and tones. However, although these qualities take priority, the underlying theme is also important. Sometimes this might simply be, for example, a colour scheme that creates a particular atmosphere. Blacks and purples may conjure up a nocturnal scene, whereas yellows may suggest a sunny day. Combined with certain marks, this may evoke a line of thought, and when further elements are added a story line emerges alongside the theme of the flower itself.

Capturing the atmosphere

By the Light of the Moon depicts stylized cow parsley placed within a painting that has been divided into colour sections. I painted dark, inky blues and purples at the top to suggest sky, while a shimmering moon throws light onto a pale landscape foreground. Although subtly textured, there is an emptiness around the flower that lends a solitary air. The story begins to emerge of a lonely moonlit walk among remembered flowers that are not quite real, such as those in a dream.

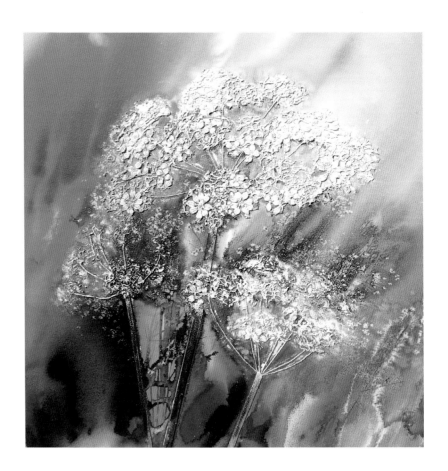

▲ **Queen Anne's Lace**
54 x 54cm (21 ¼ x 21 ¼ in)
The limited colour scheme of blues with a hint of brown creates a fantasy story line straight out of a Victorian fairy tale.

▶ **By the Light of the Moon**
43 x 36cm (17 x 14in)
In this mixed-media collage I used a lot of white paint on the raised surfaces, which lends a mystical aura to the painting as well as increasing the effect of moonlight shimmer.

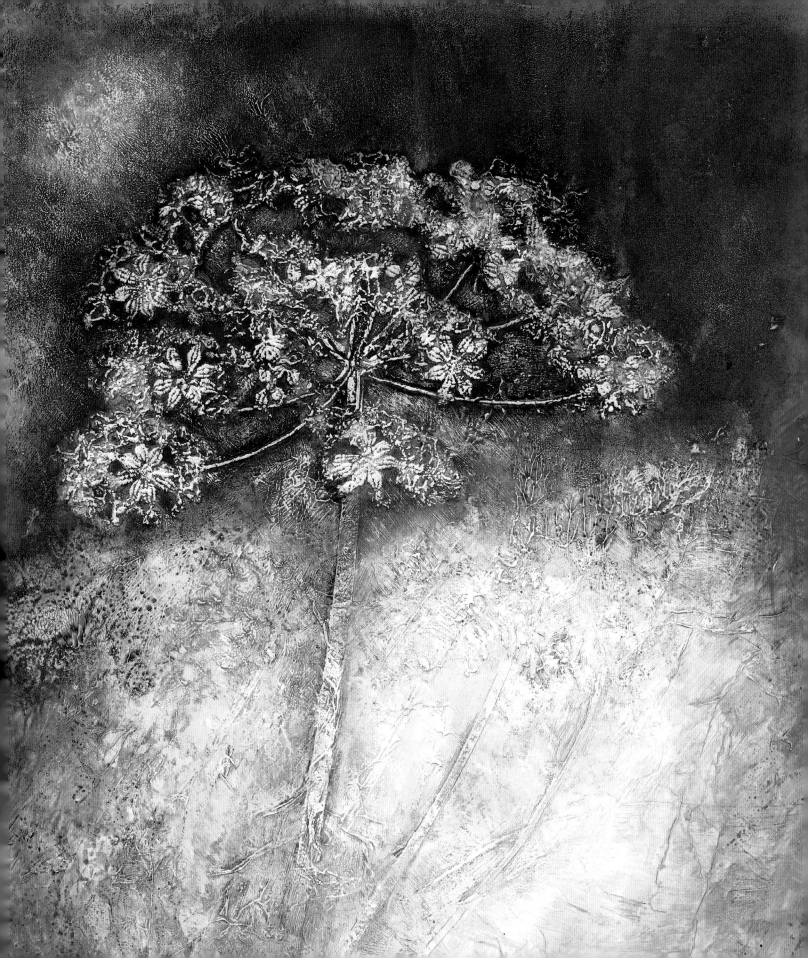

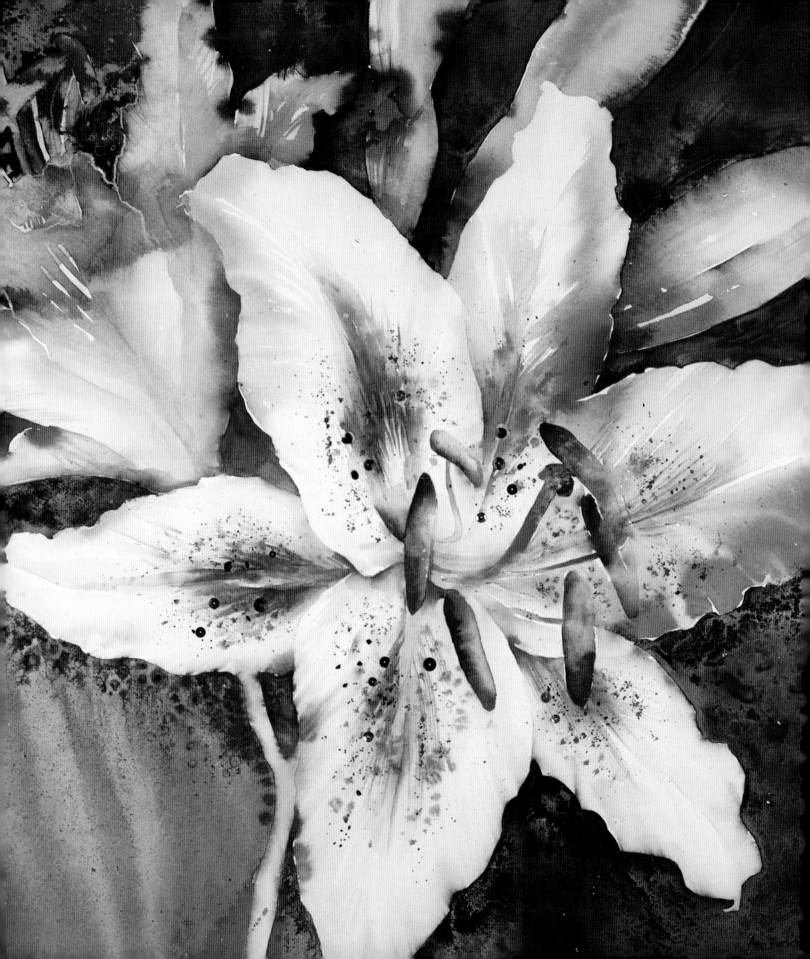

The decorative approach

◀ **Gilded Lily**
56 x 54cm (22 x 21¼ in)
I arranged the shapes of the buds and second flower in a fan around the top edge of the painting to echo the star shape of the main flower and to add to the decorative theme of the picture.

▲ **Colour experiment**
This is my colour practice run for *Gilded Lily*. I also experimented here with drawing small circles and dots with a watercolour pencil to echo the lily's patterns.

When I am deciding how to portray a subject, or elements within it, I sometimes derive inspiration from unexpected, even unconnected, sources. I made a series of lily paintings shortly after a visit to India. I had been totally enraptured by the wonderful, vibrant colours of the sari fabrics, and the intricacies of the sparkling embroideries and embellishments. On my return, the oranges and pinks of the lilies reminded me of these. In *Gilded Lily* I kept the colours as light and bright as possible and deliberately chose not to introduce any greens in the stems in order to keep to the hot colour scheme. I stuck shiny gold and pink sequins onto the petals to represent some of the decorative markings.

Using added decorations

In another version I took the name 'Stargazer Lily' and used small shiny stars to embellish my painting. Such additions may seem frivolous, but I like the idea that a painting may sometimes include elements of fun. The decorations for these pictures were ready-made, shop-bought spangles, but they made me consider what other decorative motifs could be introduced into a painting, and how it might be possible to cut one's own shapes and patterns out of gold foil or other interesting papers. I now keep a box of 'goodies' into which I put all types of sweet wrappers, paper doilies, bits of wallpaper, or anything else that may be useful for collage work or decoration.

Working from life

Sometimes you can try so hard to produce an interesting painting that you think too much and over-analyse your work. This often happens when working from photographs because there is more time for the planning stage. When you work from real flowers, however, there is a time limit. You have to put paint to paper before the flowers move, wilt or die! This pressure can be used to advantage to create very loose, intuitive work. I have already discussed the benefits of working spontaneously and the idea of painting without any pencil drawing on pages 36–7. These comments are particularly applicable to any work done outdoors or from still life inside.

A personal response

When I paint with real flowers in front of me I feel a strong connection to them; I can reach out and touch the velvet or translucent tissue of the petals and inhale their scent. If I am outdoors, I can watch the flowers swaying in the breeze, hear bees buzzing, and feel heat on my body. These factors affect my response, and because a connection is formed between myself and the subject the paintings seem to express more emotion.

▶ **Tiger Lily**
34 x 50cm (13¹/₂ x 19¹/₂ in)
I painted these lilies in a garden in southern France.
It was very hot and the watercolour dried rapidly. I had
to work quickly. You can sense the speed of the painting
in the brushwork. I used intense colours to capture the
feeling of heat.

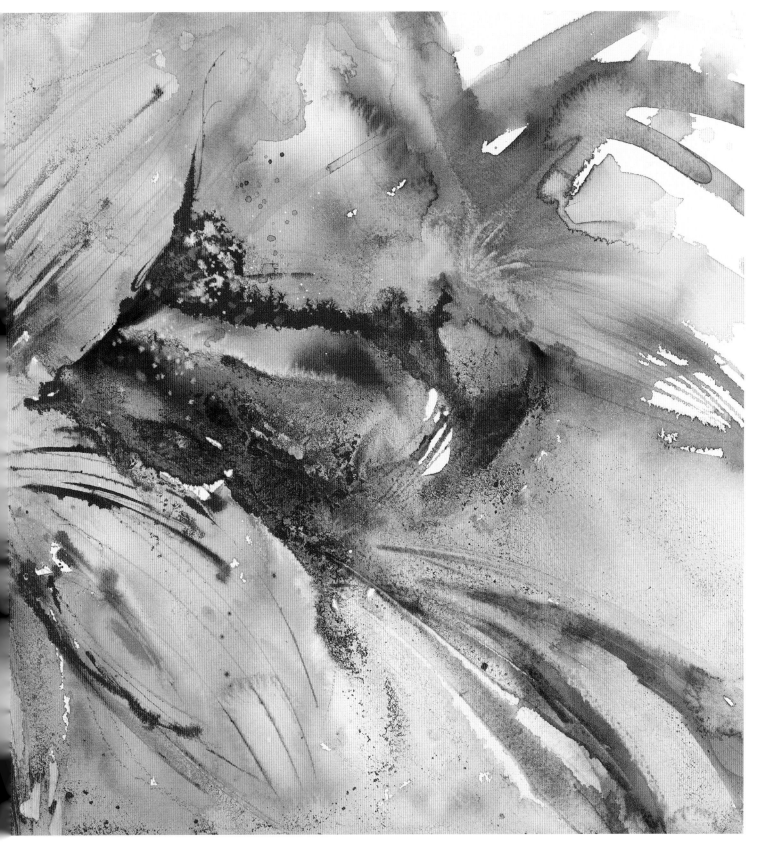

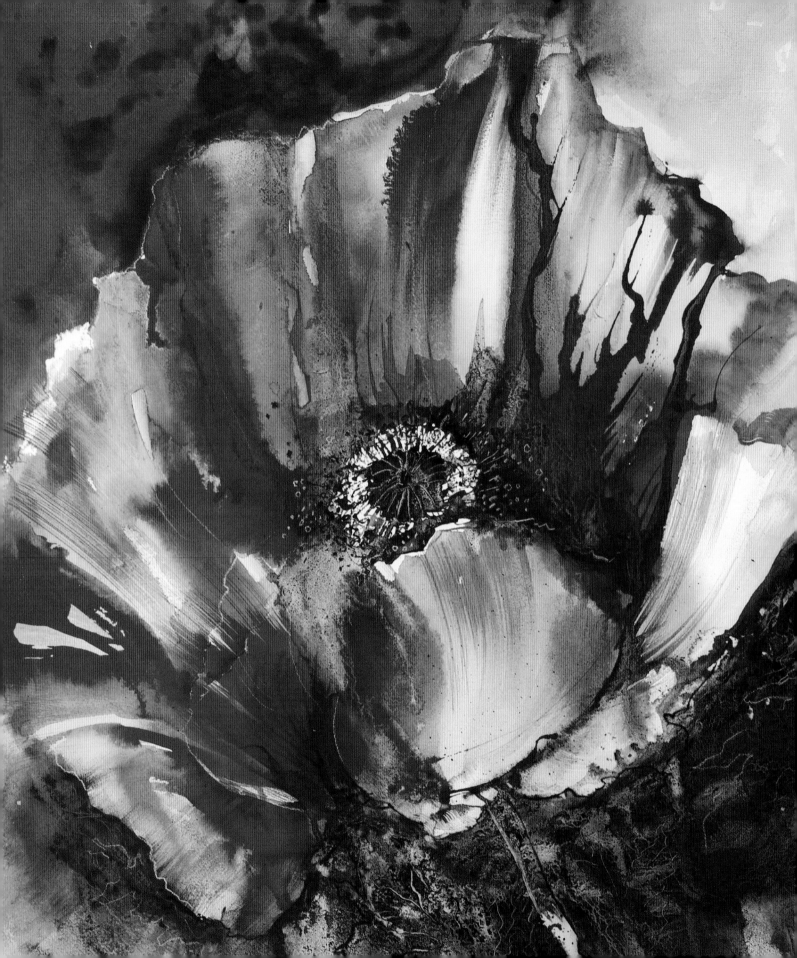

Creating drama

There are many ways to create drama in a painting. The obvious one when depicting flowers is to paint them much larger than life. I love using a whole sheet of watercolour paper to paint just one flower as it has maximum impact. I find that this works only with certain flowers, however. Painting out of scale can cause confusion for the viewer, especially if an impressionistic style is used without those details that identify the species. A flower such as a poppy, with its easily identifiable crimson colour and dark centre, keeps its character however large it is painted. A small blossom, on the other hand, could easily be confused with similar flowers. A flower that 'looks you in the eye', displaying its centre, is often more showy than one in profile.

Drama can also be created by using strong colours, such as those found in acrylic inks, which can be employed on their own or combined with watercolour.

Working on a large scale

When working on a large scale it is important to be generous with all aspects of the process. Use big brushes, such as a house painter's brush. Find bowls to mix paint in rather than mean little palettes, and above all give yourself permission to be extravagant with the pigments. Work standing up, if you can, to give yourself distance and the freedom to move your arms.

◀ **Portrait of a Poppy**

67 x 55cm (26½ x 21½ in)

I filled a whole sheet of paper with this single flower so that it would make a sensational statement when framed on someone's wall. I avoided prettiness by using plenty of hard edges, dribbles and a dark, moody foreground.

▲ **Red and Blue Poppy**

17 x 18cm (6½ x 7 in)

The orange-red of this poppy is a dramatic contrast to the complementary blue background. In this version, maximum impact is achieved by keeping the painting simple, with very little detail in the petals. The joyous flow of colour from one area to the next gives movement to the flower.

Emphasis and echoes

If there is an aspect of a subject that especially pleases me or is particularly relevant, I will emphasize that quality and avoid any ambiguity as to where my chief interest lies. For example, I love painting poppies, not because they are pretty subjects but because they are so very red! Ways of emphasizing the colour may be through tonal contrast or by using a complementary colour. I sometimes echo the scarlet theme by adding another crimson elsewhere in the painting. This could be as little as an abstract mark or a more significant feature, such as the moon in *Scarlet Moon*, opposite.

Echoing shapes and marks

Echoes might also be in the form of a texture or a shape found in the flower. Poppy seed heads make wonderful little shapes for mimicking elsewhere in a painting, as do the sinuous lines of the frail wild poppy stems. Repetition of abstract qualities such as these helps to create a strong and personal statement.

◀ **Summer Storm**
12 x 12cm (4³/₄ x 4³/₄in)
Hard-edged flashes of white pick out poppy petals from loose washes of red and a stormy sky. As these are the only crisp highlights, they really emphasize the importance of these shapes.

▶ **Simply Red**
31 x 31cm (12¹/₄ x 12¹/₄in)
Red poppies on a red background make a strong colour statement. Tiny spots of blue added to the centre with oil pastel provide the only other colour apart from black, and the contrast serves to emphasize the theme.

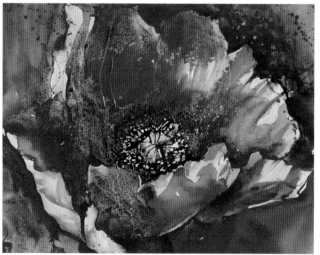

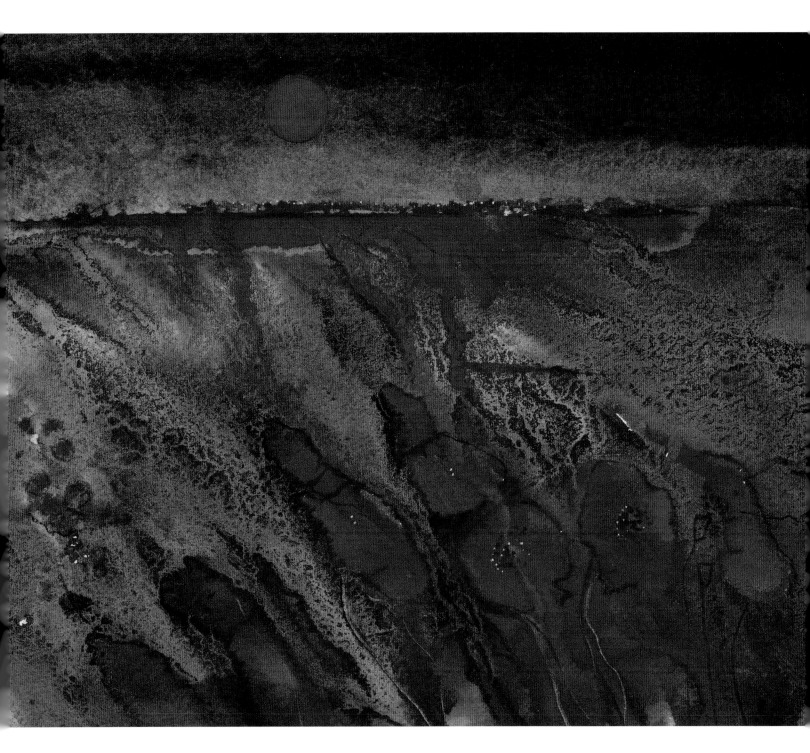

▲ **Scarlet Moon**

16 x 20cm (6¼ x 8in)

Dribbles and meandering stems lead the eye towards the sky where a red moon echoes the
rounded shapes and colour of the poppies.

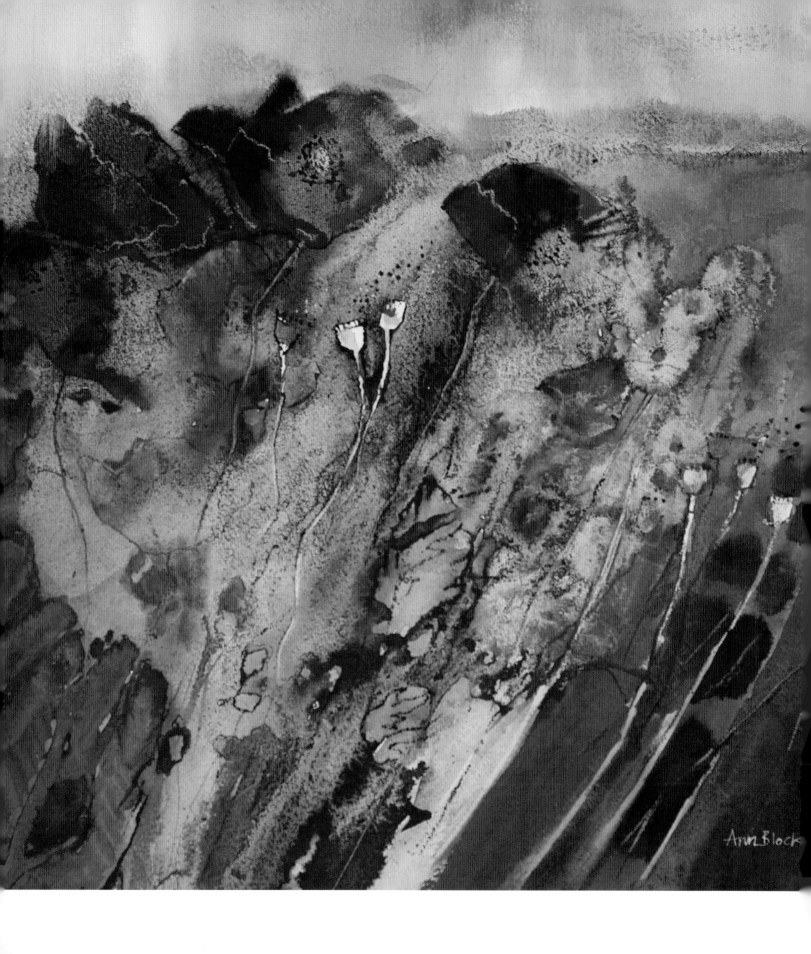

Looking for abstract qualities

I try to look at subjects for their abstract qualities as far as possible. In order to get away from a straight representation of a subject it is important to view it in a different way. Observing and emphasizing the spaces between subjects is a great way of creating a more abstract interpretation. If the negative shapes are perceived to have as much importance as the positive ones, interesting patterns will emerge.

Seeing shapes

When I am writing I have to use botanical terms such as 'petal', 'stamen' and 'leaf' in order to communicate with the reader and identify certain parts of a painting. However, when I am painting I think of these features in abstract terms such as 'curved edge', 'straight line' or 'wriggly scribble'. When your brain thinks like this it helps to release you from the desire to be 'accurate' in a photographic or botanical sense. You begin to exaggerate and interpret shapes in an expressive and individual fashion. The boundaries melt and a more abstract style develops.

◀ **Poppy Meadow**
27 x 27cm (10¹/₂ x 10¹/₂in)
I painted wet-into-wet washes of watercolour and then brushed patches of gouache on top to develop positive and negative shapes. These suggested poppies and the spaces between stems. Dots and sinuous lines of black watercolour pencil were enough to indicate poppy centres, floating seeds and stems.

▶ **Colour experiment**
This is a colour experiment that I made before starting a portrait of a poppy, to try out suitable marks, colours and textures. Sometimes I work on top of an uninhibited pattern such as this and turn it into an abstract landscape.

Experimental flower centres

When painting a flower centre I like to look at it for its painterly qualities and see the flower parts in terms of mark-making. Stamens and pollen, for example, can be portrayed as a series of dots or lines. The tip of a palette knife can be used to splatter a fine dusting of paint, and the edge of the same knife can be used to draw fine lines of watercolour. Dots of wax crayon or oil pastel can represent chunkier markings.

Using different techniques

In my sunflower series I became involved with ways of describing the large centre, with its countless small seeds. In this set of experiments I was not concerned with the intricately arranged spiral patterns that the seeds make, although these are fascinating, but simply their repeated round shapes. I explored different methods to represent this idea. For example, in one version I prepared a flower centre with the glass-bead gel that is normally added to acrylics. In other experiments I tore holes in the paper surface, stuck collage onto it, broke up the watercolour with granulation medium, or used different materials to draw or print small circles.

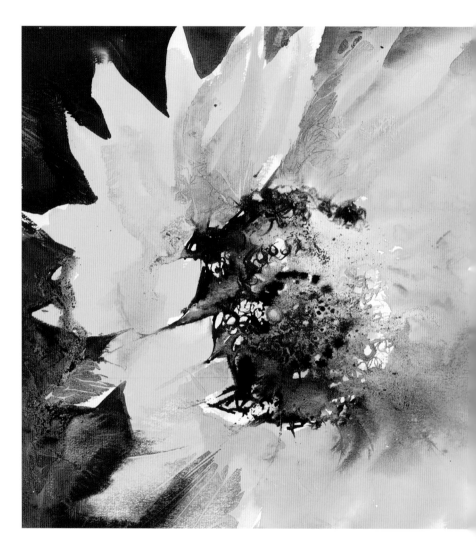

▲ **Sunflower 1**

44 x 38cm (17¼ in x 15in)

I brushed a wash of yellow watercolour into the flower centre and drew dots and squiggles of Indian ink into the paint. I immediately poured a little granulation medium into this to break up the ink into a granulated texture.

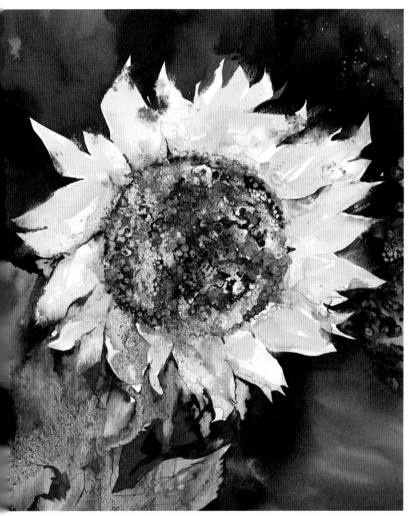

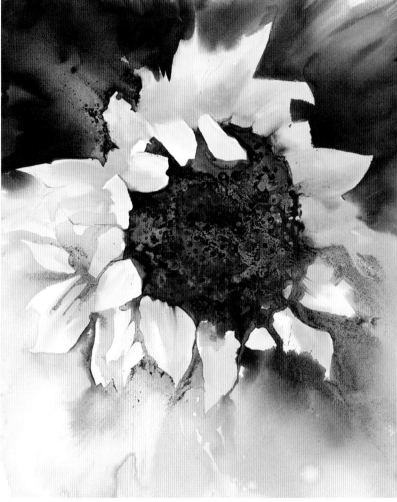

▲ **Sun and Stars**

56 x 38cm (22 x 15in)

Inspired by the name of the flower, I had the whimsical idea of developing a theme of suns and stars. I painted a night-sky background with splatterings of gold ink that echoed the circular shapes in the flower centre. The sunflower was made part of a magical constellation.

▲ **Sunflower 2**

56 x 47cm (22 x 18¹/₂in)

In this rich flower centre I added dots and circles of gold ink in ring-shaped patterns to echo the design made by the seeds. I also drew some tiny seed-shaped circles into the wet paint with a black watercolour pencil.

Using paper collage

During my exploration of sunflower centres I decided to stretch the boundaries beyond manipulating the paint to the paper surface itself. Cutting and sticking was one of my favourite childhood activities. I believe that in a search to move forward it can be valuable to revisit past hobbies or interests, especially those enjoyed before adulthood.

Building up layers of paper shapes suggests opportunities for describing the overlapping effect of petals or other three-dimensional elements. Alternatively, a paper collage can simply act as an unusual abstract interpretation of certain shapes. Paper can be cut or torn out and reassembled, using PVA glue, in an infinite variety of ways.

Reflecting the plant's character

In my sunflower experiments I was sensitive to the nature of the plant's different parts. In *Sunflower, Cut and Torn* I used cut edges to describe the crisp petals that curled over the middle but torn ones to represent areas within the rough, seeded centre. I tore holes out of the paper and even attacked the surface with a scalpel, picking out small perforations. In *Sun and Stars* I stuck small overlapping circles of paper into the sunflower centre before I began painting. The watercolour gathered around these raised edges to emphasize them. I rubbed gold paint over the embossed shapes when they were dry to create a slight sheen and make the circles more pronounced.

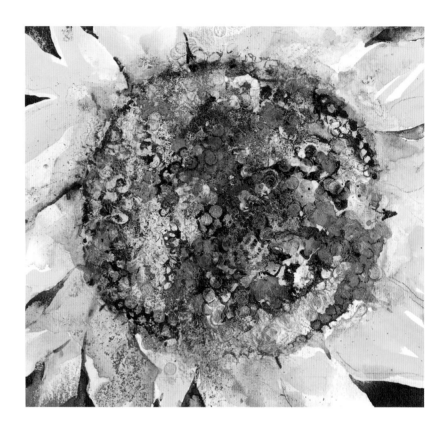

▲ **Sun and Stars (detail)**
The seeds in this flower centre were represented in an abstract shorthand using collage built from paper circles made with a hole punch.

▶ **Sunflower, Cut and Torn**
56 x 47cm (22 x 18½in)
I cut out the sunflower centre, using a scalpel to create sharp-edged petals, and tore the paper to make ragged edges. I roughly tore concentric circles of paper and layered them to create a textured collage on which to paint.

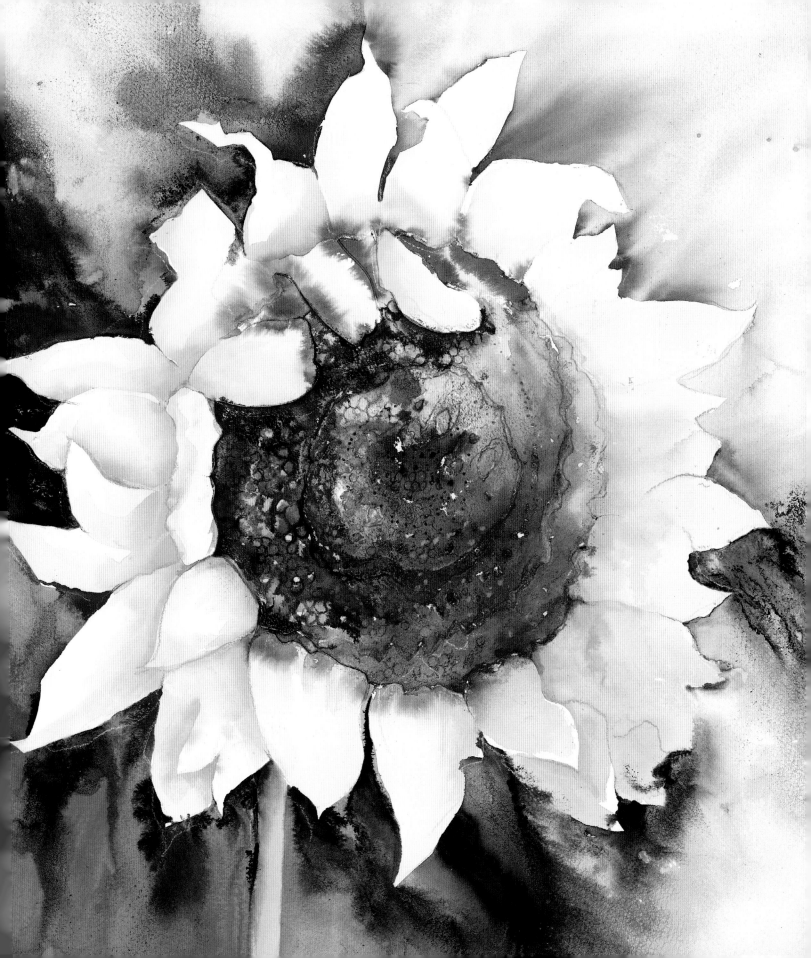

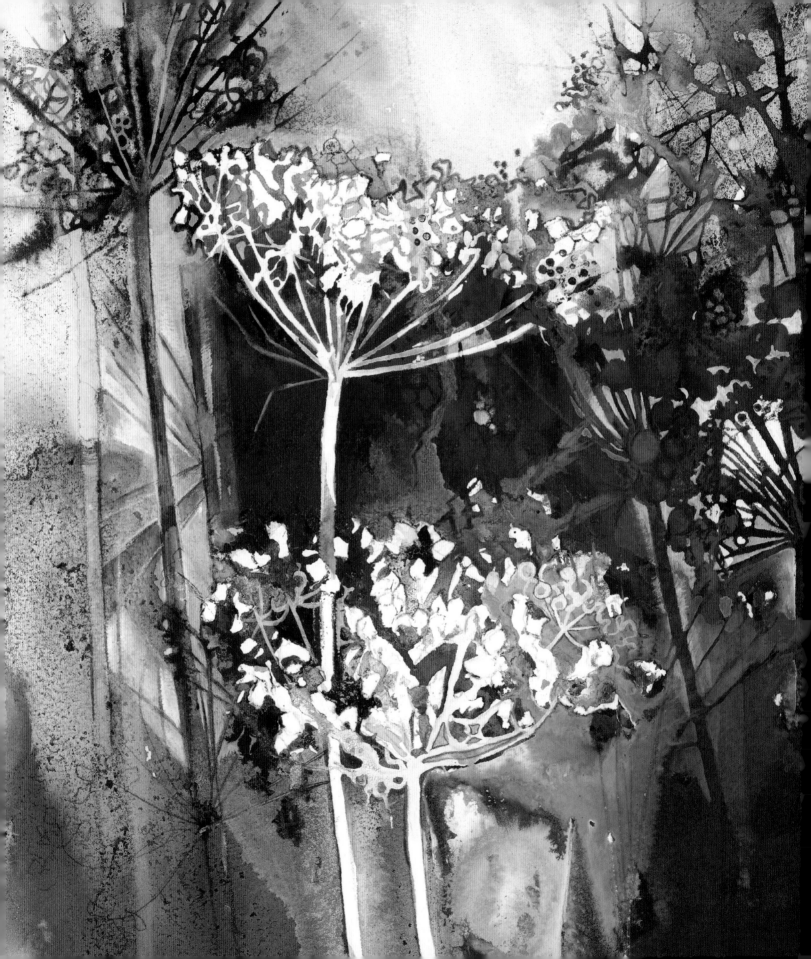

Autumn and winter

In the autumn and winter there are fewer flowers with their obvious attractions, which means that you have to search for more unusual subject matter. The textures, tangles and shapes of leaves, hedgerow berries, seed heads and winter skeletons all offer exciting potential for creative experiments. Their graphic patterns point towards more abstract interpretations, using a variety of unusual mark-making devices, different surfaces and collage. Inspiring design opportunities and subjects help you to stretch the boundaries of your imagination.

◀ Hedgerow Patterns
30 x 38cm (12 x 15in)

Vibrant colour

To capture the vibrant colours of autumn leaves it is important to keep the watercolour fresh and clean. Working loosely and quickly will help you to avoid the temptation of overworking, which can result in muddy colours. Using complementary colours such as blues and oranges will make colours sing. Sometimes vibrancy can also be achieved by placing strong tonal contrasts against a light, bright hue.

I am very generous with my pigment. I use lots of paint and plenty of water as you cannot obtain strong colour without a potent mixture of watercolour. If I get too frustrated with the way that this medium can fade as it dries, I turn to acrylic inks. These are wonderfully vivid and can be used straight from the pot, diluted or mixed with watercolour.

Sparkling light

The best way of creating light in a watercolour is to leave areas of white paper. Sometimes I leave unpainted patches to indicate, for example, the gaps through trees and leaves. Small areas of dark colour against a pale or white background can increase the intensity of light. Occasionally I create sparkle by brushing sparingly over the paper's irregular surface to leave speckles of light. Adding salt to a drying wash is another great way to suggest sparkle, such as dappled sunlight.

▲ **Autumn leaves sketch**
Sweeping, decisive strokes made with a flat brush produce a dazzling quick impression of dancing autumn leaves.

▶ **Autumn Glory**
46 x 30cm (18 x 12in)
Acrylic inks combined with watercolour create vibrant hues.

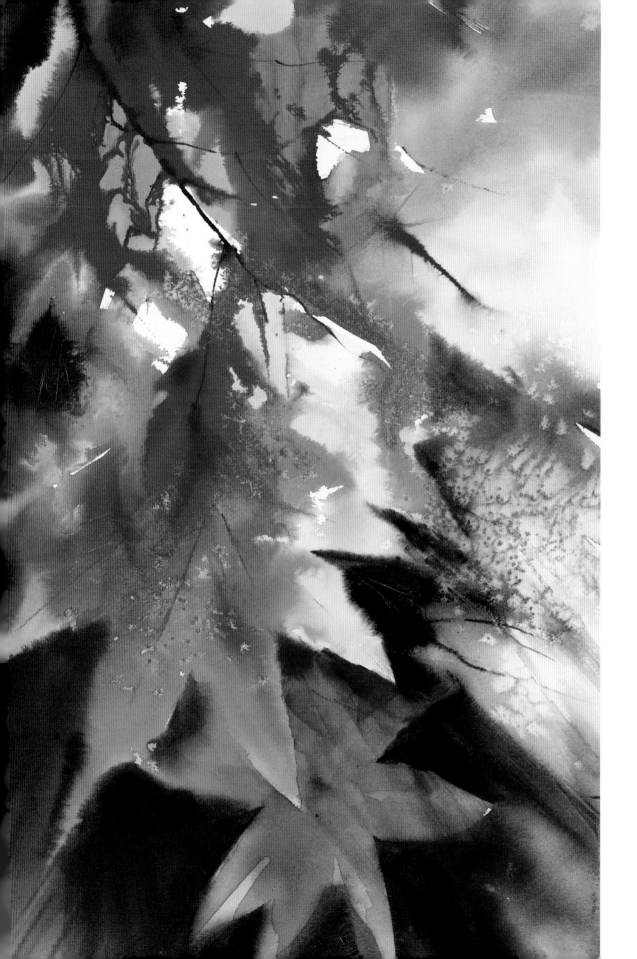

Paint textures

Painting thistles is an exercise in texture-making. There is a huge contrast between the soft, fluffy topknot and the spiky stems and leaves. I try to find ways of expressing the difference between the parts of the plant by employing appropriate techniques or media. Sometimes I choose a textural theme that can run through the whole painting.

Using contrasting styles

In *Thistles 1* I wanted to retain a sharp, chiselled style so I used masking fluid to mask out all the main negative shapes, especially those where the thistles stood against the sky. This gave me the freedom to brush strong, dark washes into the positive shapes of the flowers and stalks, creating a clean, graphic, woodcut effect.

In *Thistles 2*, another version of the previous painting, I decided to aim for the opposite effect. This time I played on the soft qualities of the thistle flower and floating drifts of thistledown. I painted the plant forms in watercolour washes and then worked over these when they were dry, using gouache. By keeping the pigment quite dry I could smudge the edges and create a blur that suggested the movement of the drifting seeds and shimmering light.

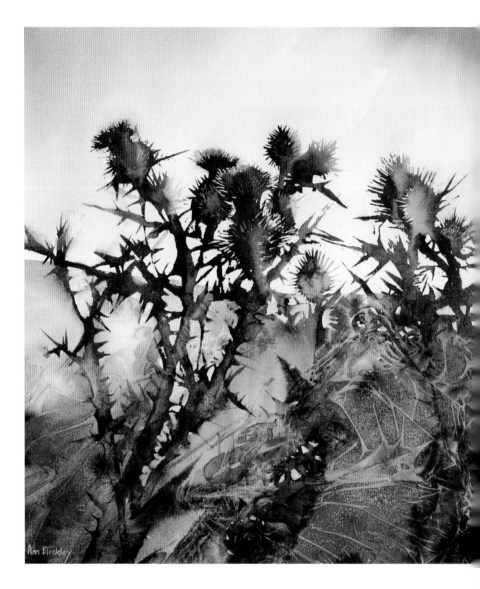

▲ **Thistles 1**
39 x 39cm (15¹/₂ x 15¹/₂in)
The sharp profile and spikes of the thistles gave me the idea of keeping to a hard-edged silhouette at the top of the plant. I allowed washes to flow softly within each contained area.

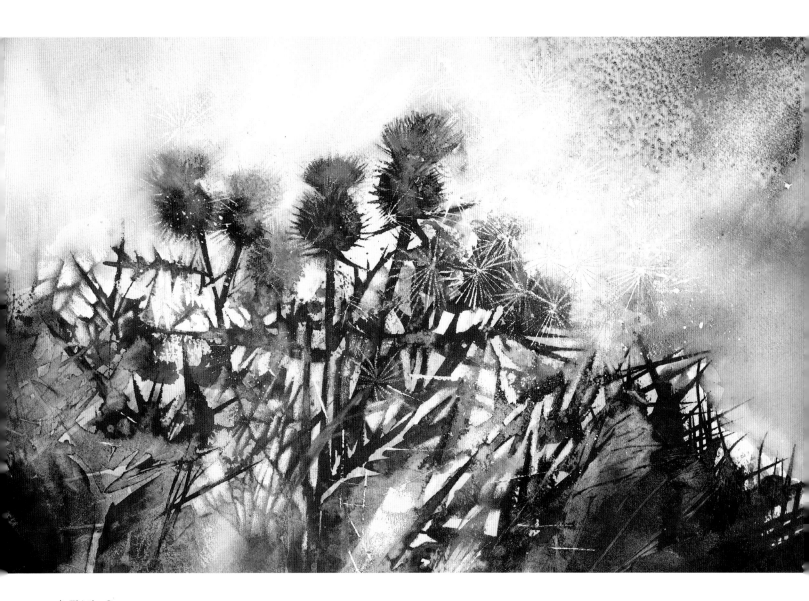

▲ Thistles 2

30 x 30cm (12 x 12in)

I like using the opaque property of gouache to work over a dark wash and create new pale areas, such as the light dazzling through gaps between the stems and leaves.

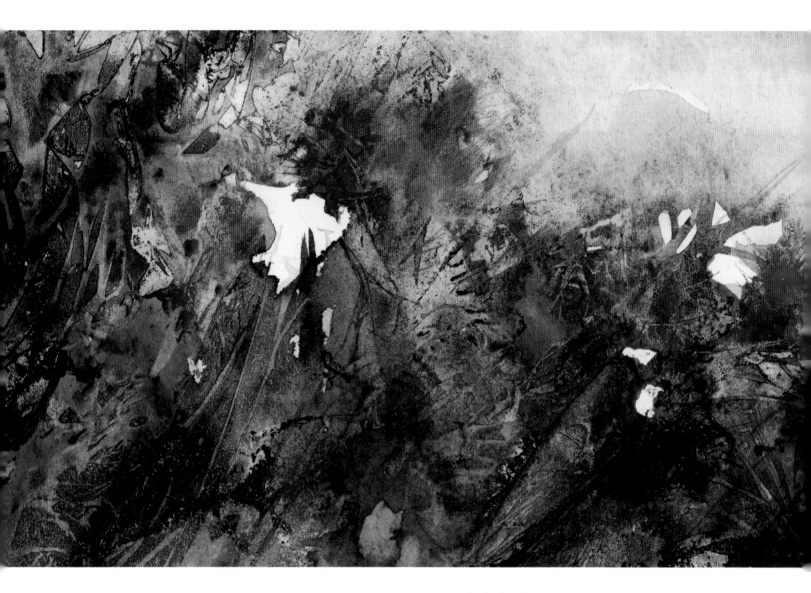

▲ Thistle Whispers

The softness of the fluffy thistle flowers is perfectly described with a blur of wet-into-wet watercolour. Further definition could easily spoil the magic.

Leaving something to the imagination

▲ Thistle experiment
Clingfilm applied to a wet wash has disturbed the paint into marks
that hint at spikes and leaf shapes.

Expressive paintings are often those containing the least amount of work. If you explain everything in detail, there is nothing left to imagine. I prefer to give hints about the identity of a subject. The profile of a plant may be drawn carefully, but certain botanical features or details may be left out or just suggested with a simple mark. Sometimes the subject's colour might be so evocative that the merest whisper of further information is all that is needed to indicate the plant's identity.

Providing visual clues

Focus on giving one area of your painting the most detail, but be more selective elsewhere. It is a bit like the game 'twenty questions', where you give the other players small snippets of information one at a time until they can guess the subject. In a painting you use visual rather than verbal clues. In both Thistle Whispers and Thistle Experiment, the biggest clues are the pink smudged shapes which represent the flowers themselves. The spikes on the flower bases, stems and prickly leaves are summarized through scratchy lines and zigzag shapes.

Finding your own style

For many artists, finding a personal style is the hardest thing to achieve. When you first learn to paint you are more concerned with techniques than style, but when a certain level of accomplishment is reached you usually want your work to say something unique and individual. While this often elusive quest for originality is best furthered through experimentation and practice, it is also vital to have a passion for your subject. I love to walk in the countryside, and hedgerows are a constant source of inspiration, with their multitude of plant life woven together into ever-changing patterns. I am grief-stricken if farm machines chop my beloved hedges and this emotional involvement with the subject shows in my work.

Revisiting old ideas

My painting handwriting emerged naturally as I learnt to paint. Now that I am trying to stretch my work further, the boundaries have been moved and I am having to work even harder to discover the direction in which I want my style to develop. When the autumn hedgerow began to show its first flowers and fruits I decided to begin my annual explorations using familiar formats, as I had done at the start of spring. This way I could gently remind myself about the hedgerow shapes, colours and patterns, like catching up with an old friend. Ideas began to bubble as I painted in my traditional style, which gave me the confidence to step outside my comfort zone in subsequent autumn paintings.

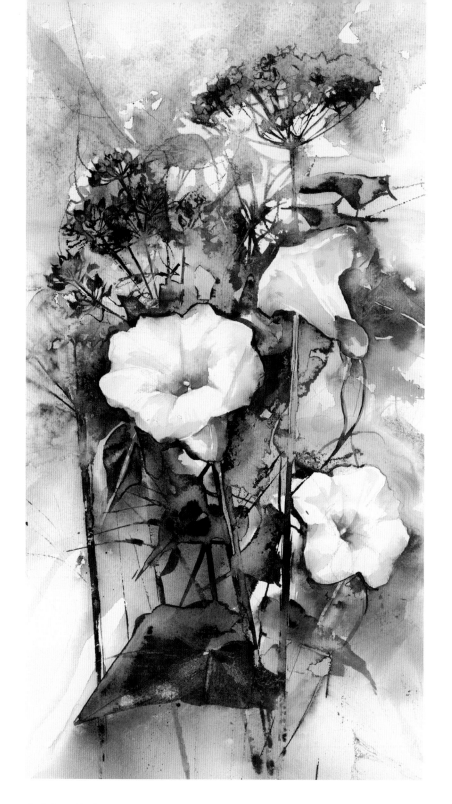

▲ **Autumn Hedgerow**
46 x 27cm (18 x 10½in)
This painting explores the way that bindweed relates to the intermingling of stems, leaves and hogweed umbels. Some of the stalks were painted with a brush, but others were printed with the edge of thin card.

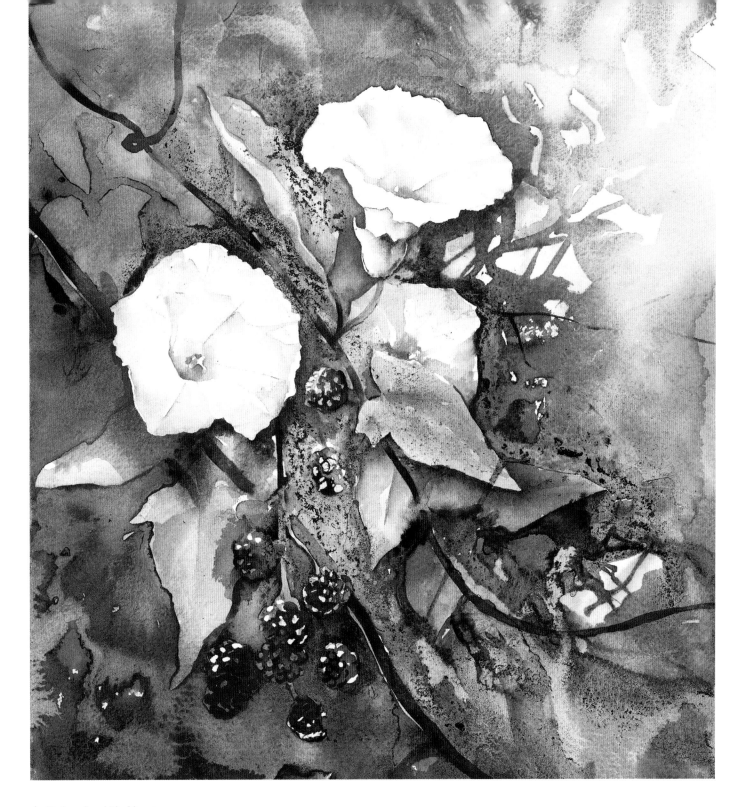

▲ **Bindweed and Blackberries**

29 x 24cm (11 1/2 x 9 1/2 in)

In this painting I explored my favourite themes of flowing washes, edge values and shapes. The
subject evokes an almost Victorian feeling that I wanted to look at in a relatively traditional style.

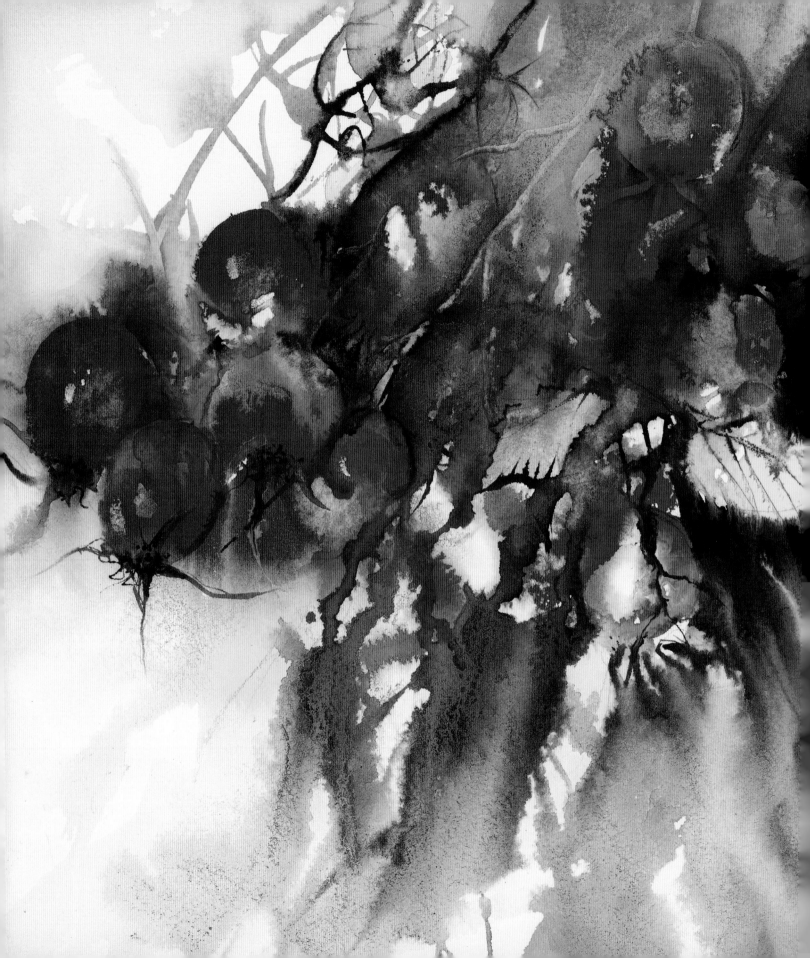

Hedgerow tangles

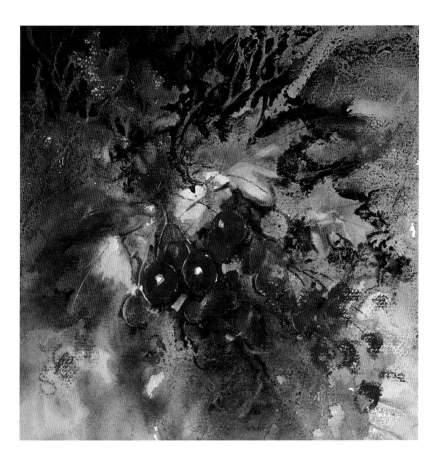

◀ **Autumn Magic**
25 x 25cm (10 x 10in)
Here, paint was dribbled in a diagonal direction to suggest rose stems. I also drew into the wet washes with a watercolour pencil to describe leaf veins and edges. When there is no obvious focal point a design becomes an abstract pattern, such as in this detail.

▲ **Autumn Treasure**
25 x 25cm (10 x 10in)
The dark fretwork of stems at the top of the painting leads the eye towards the main group of berries. I used oil pastel under the watercolour to create sparkle where it caught the raised surface of the Rough paper. The pale twiggy shapes were made by scraping away thick, dark paint with a scalpel.

The hedgerow is like a tapestry, with its complex interweaving of subjects. The myriad shapes of berries and leaves are linked by an embroidery of branches, twigs and stems. Artistically, this is an opportunity to create stunning designs. The key to success in structuring a composition from such an intricate subject is to be extremely selective and concentrate on just one section. The temptation is to include everything, but a stronger statement is achieved when only certain aspects of the subject are chosen for emphasis.

I use the network of plant life to draw visual pathways in my designs, leading the eye through the painting towards the focal point. This may be a vivid autumn leaf, a lonely winter rosehip, or it may be just a patch of light through a tangle of foliage, or an area of interesting colour or texture.

Using linear marks

The tangle of twigs and stems that builds a hedgerow can be represented in a painting as a series of linear marks. Depending on the species to be portrayed, these may be sinuous, curved, zigzagging or spiky. They vary in thickness from delicate traceries to chunkier marks. There is a huge choice of ways in which to make these lines, from using traditional brushstrokes to printing with the edge of a card or scratching out paint from a wash. Sometimes I let paint simply dribble to suggest the direction of a stem. I also draw underneath or on top of the watercolour to make appropriate marks, using oil pastels, wax crayons or a variety of different pencil types.

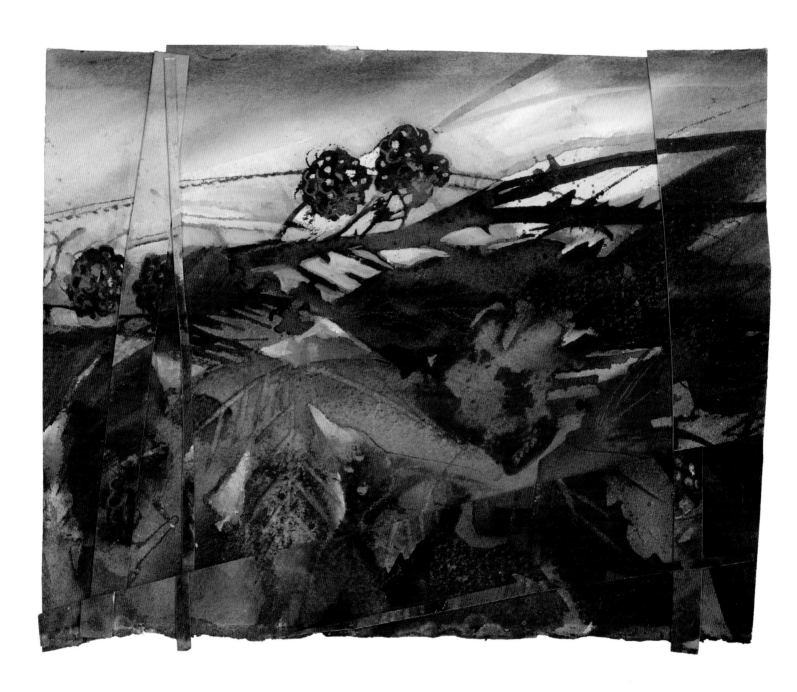

▲ **Brambly Hedge**

16cm x 20cm (6¼ x 8in)

I painted arching brambles with conventional flowing washes. When these were dry I applied white gouache to create negative shapes. I then sliced up strips of the painting and repositioned them back on top of the original picture. This sharp-edged fracturing of the image captured the mood and complex pattern of thorny brambles.

Torn and cut paper edges

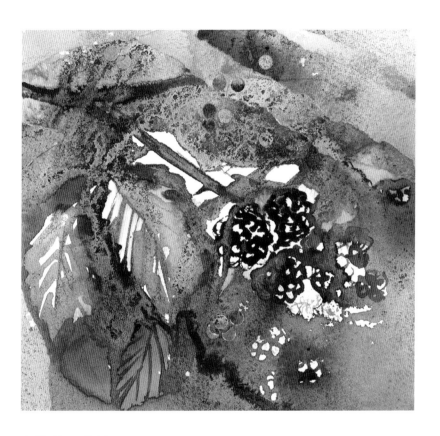

▲ Blackberry Patch

17 x 17cm (6¹/₂ x 6¹/₂ in)

I punched holes out of scraps of watercolour painting and stuck the circles onto a picture.
The tiny perforations and round shapes echoed the small fruity globes of the blackberry.

Having looked at ways of using paint to describe edges and lines, I continued experimenting with paper collage to represent different edge values. By cutting or tearing paper into shapes either before or after painting I am able to achieve crisp or rough edges that can echo those of my subject. For example, as bramble branches are smooth but viciously spiked with thorns, I may cut along the edges, whereas a torn edge would be more appropriate for portraying rough and knobbly twigs of oak. Sometimes I apply more abstract collage shapes to a background, roughly based on shapes within the subject.

Achieving different effects

As watercolour paper is quite thick and formed of layers, the action of tearing it becomes an art in itself. The direction in which painted paper is torn creates either a ragged white rim of varying widths or a coloured edge. Once the paper has been prepared I reassemble it, often misaligning shapes to create tension or a quirky viewpoint. Occasionally I add extra layers of watercolour or collage pieces on top to develop a more complex composition.

Working creatively

I have a big drawer in which I keep my unfinished paintings or the pictures that I am not happy with. Every now and again I look through these to see if I can view them in a fresh light and make improvements. I keep my paint experiments in the same place and also the pieces that I have trimmed off bigger paintings when I crop them for framing. Some of these watercolour pieces are exciting abstract images and I enjoy looking at them when I need a creative boost.

Interpreting paint effects

Autumn in the Air was created out of a strip of watercolour that I had cut off the side of a huge painting of a poppy. I had decided that the rectangular flower painting was more dramatic as a square so I chopped a section off. As this piece contained some interesting paint effects, I kept it for future reference. When I looked at it later in the year I saw that its red colours and types of texture suggested an autumn hedgerow with hips and haws. I worked into it, adding positive and negative shapes to conjure up arching branches and berries. I used white gouache to pull pale shapes out of dark watercolour where necessary. I had no plan when I began this painting and found that I was working in a satisfyingly creative way by following my intuition.

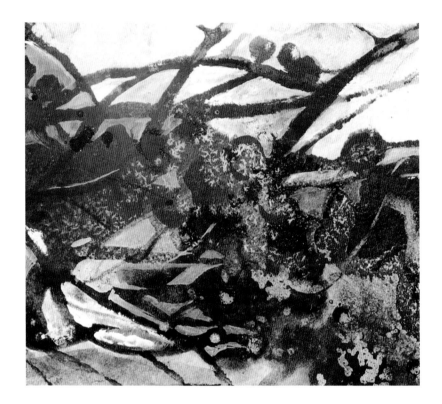

▲ **Autumn in the Air (detail)**
Adding small smudges and marks of red paint turned a brown texture into impressionistic berries.

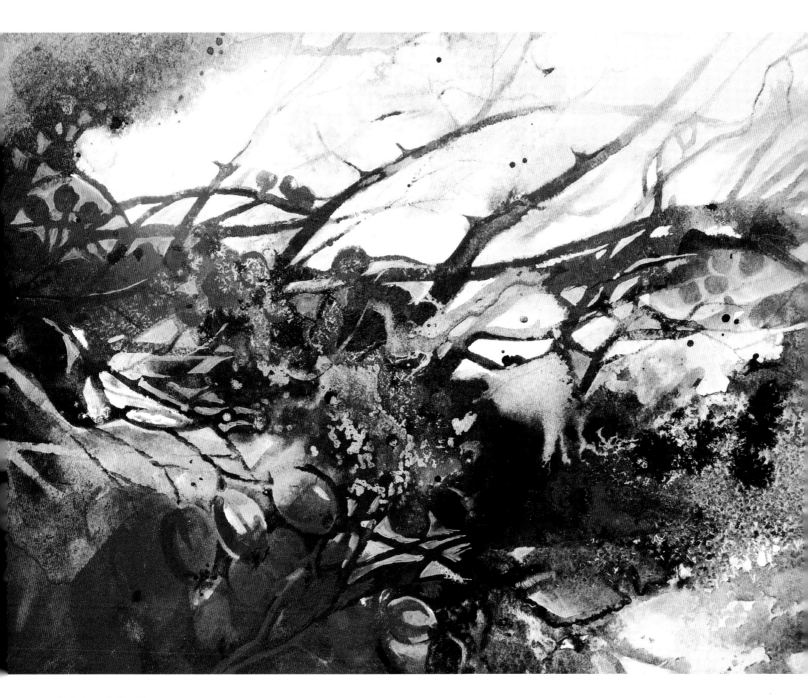

▲ **Autumn in the Air**

18 x 20cm (7 x 8in)

When I develop an experiment or colour sketch into a finished painting I will look at it from all angles before I begin, as different viewpoints can affect what subject is suggested in the paint. This landscape-shaped painting was created out of a vertical offcut.

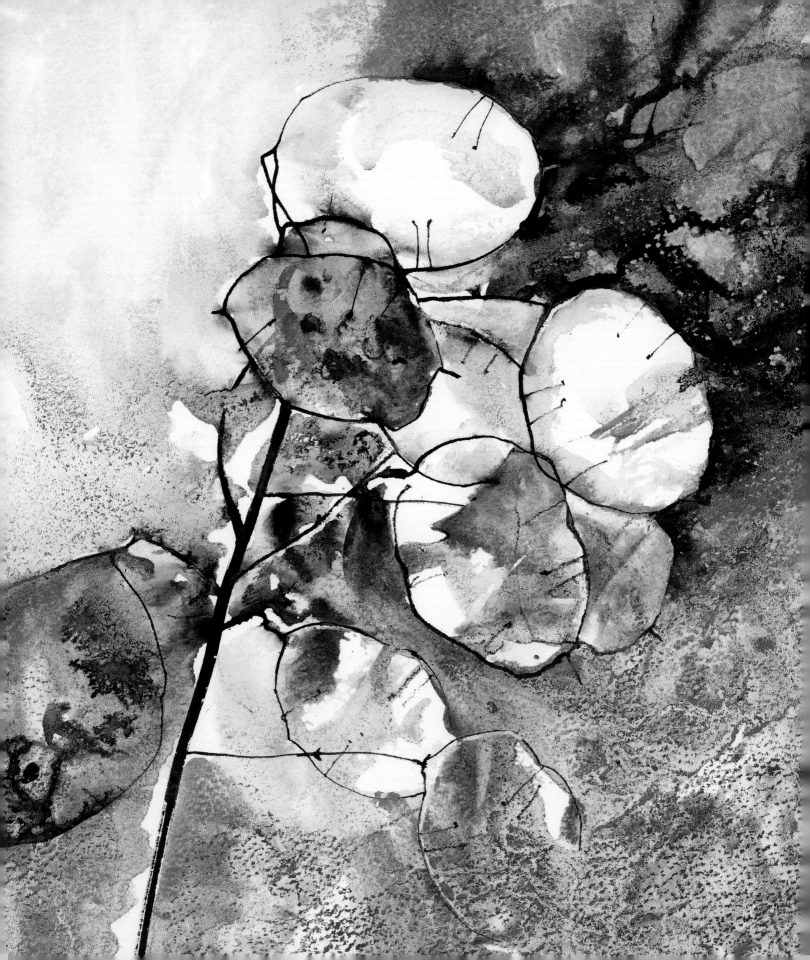

Shapes and pattern

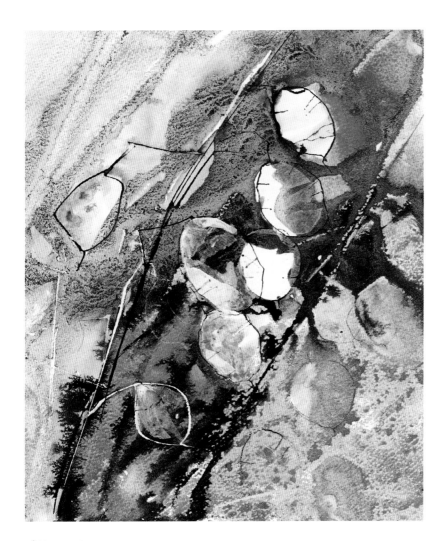

My favourite time to paint honesty is in the winter when the silvery seed cases have formed. The seeds are 'stuck' to a translucent disc that is revealed as the weather tears away the thick outer skins. These are more opaque, which makes the plant's degree of transparency vary depending on how many layers are left. Once uncovered, the filmy inner surface becomes increasingly torn and shredded into twisted abstract patterns. The ring of fibre that held the whole structure together remains, but it too can break eventually and distort into fascinating contortions.

What makes this plant so unusual is that it has this fibrous outline that appears pale if viewed against a dark background but looks black if seen against the light. All these botanical factors are critical in providing unique design opportunities. Opaque and translucent oval shapes overlap, with or without pale or dark outlines, to create abstract shapes and patterns that you do not see in any other plant.

◀ **Honesty 1**

30 x 27.5cm (11 3/4 x 10 3/4 in)

Drops of Indian ink in a damp wash create mottled textures in the opaque seed cases, which contrast with the paler translucent shapes.

▲ **Honesty 2**

30.5 x 25cm (12 x 9 3/4 in)

I cut pieces of tissue paper into oval sections and glued them in layers onto parts of the honesty. I stuck some onto the surface prior to painting and some on top afterwards. The translucent paper bears an astonishing resemblance to the actual seed cases.

Using a restrained palette

Restrained palettes of subtle mixed pigment create neutral tones that perfectly convey the moods of autumnal mists or wintry weather. By this time of year seed heads have either faded or darkened with rain. Colour is reduced and subdued to shades of grey. This does not mean that they need to be dull or boring, however, as there are endless variations of warm and cool greys. These can be produced by combining two complementary colours, such as red and green or violet and yellow. Alternatively, you can dilute ready-made pigments, such as Payne's Gray, Sepia or Mars Black, to make mouth-watering neutrals. I try to use several variations of grey or brown in a painting or wash to keep these colours interesting and to create atmosphere.

▶ **Poppy Seed Head**
30 x 13cm (12 x 5in)
I mixed a variety of dilute browns and greys, using traces of blues and mauves to add a hint of colour. I let the washes define some of the shapes, but drew certain details with a black Conté pencil.

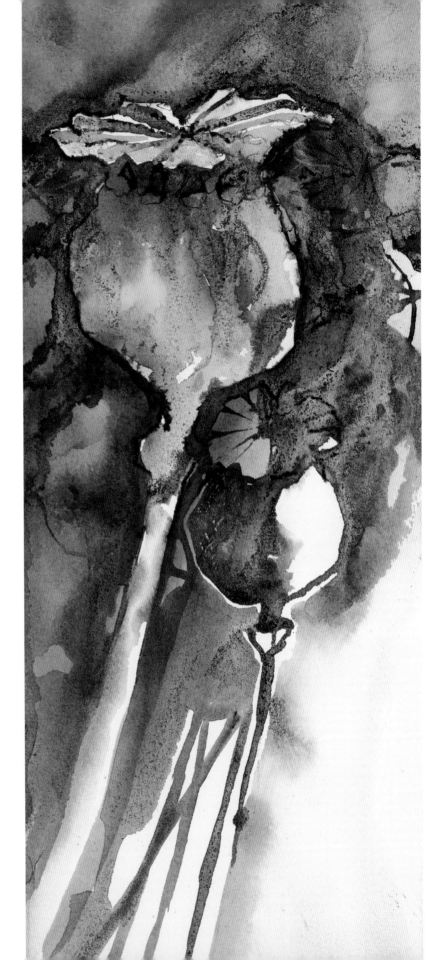

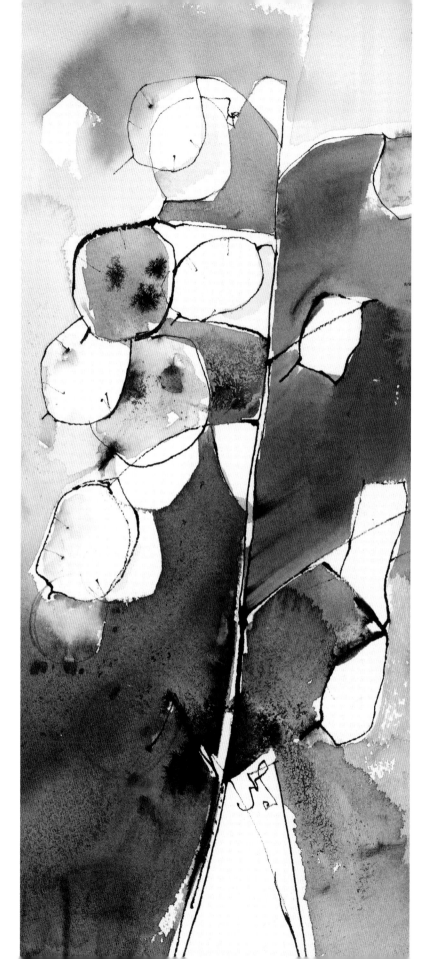

Coloured drawings

Drawing and making sketches of flowers can really help you to understand and become familiar with their shapes and structure. I like to turn my sketches into designs by adding washes of colour that reflect the character of the plant. In my Honesty sketch I filled in some of the positive and negative shapes with shades of subtle brown and turquoise. These were colours that I had noticed on parts of the seed heads where they had not cast off their outer layer. I added speckles of Indian ink to echo the mottled texture of some of the honesty shapes. I retained a few areas of white paper, which lent the drawing a somewhat Japanese style.

◀ **Honesty sketch**
33 x 15cm (13 x 6in)
I drew the honesty with a pen and nib dipped into Indian ink, varying the quality of the lines. I filled in some of the shapes with subtle colour to make a patchwork design.

Tonal values

I often look at subjects through half-closed eyes. This helps me to ignore incidental details and concentrate on the main blocks of tone. Simplifying my view of the tonal range in this way enables me to plan an effective composition and give it greater impact. In the first instance I look for the overall pattern of lights and darks, adding smaller details of tone only if they are relevant to the subject.

In *Seed Head* I painted a large close-up of a poppy seed head, placing the pale shape against a contrasting dark background. This dramatized the subject by creating a sharply illuminated effect. I described the three-dimensional form by using different tonal values. I wanted it to look sculptural and important, and deliberately kept hard edges to emphasize the tonal contrast further.

Tone and pattern

Sometimes the subject or mood of a painting demands that its solid form is described. This is usually defined by the way that the light falls on it and results in a very realistic interpretation. If a more impressionistic, even abstract, style is required, one way to achieve this is to ignore the three-dimensional qualities and reduce them to flat areas of colour or tone.

In Seed head patterns (opposite) I looked at positive and negative shapes in almost black-and-white terms. The darks against lights are dramatic, but the strong tones set against very similar values are quite subtle. The design is more of a pattern than a representational study.

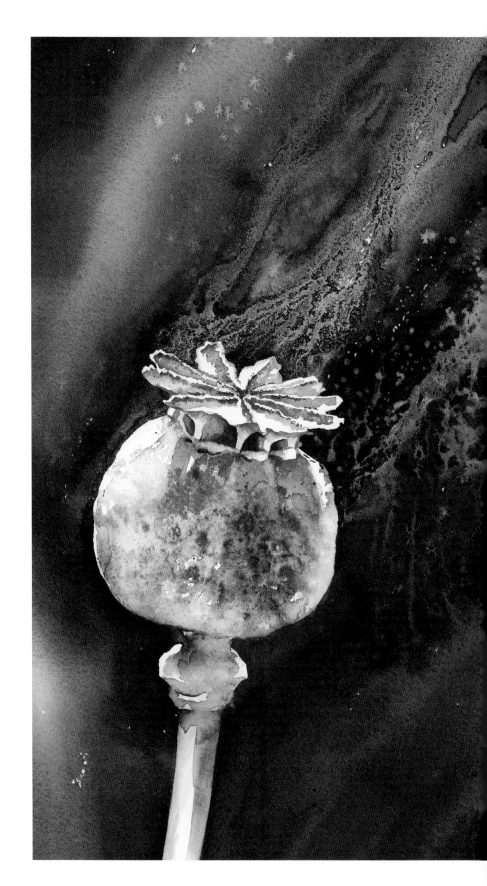

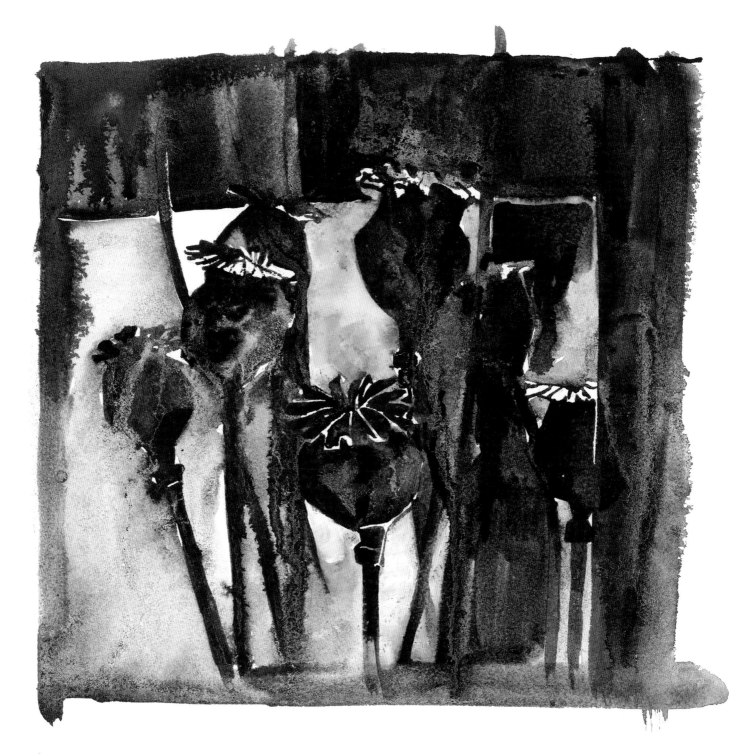

◀ **Seed Head**

30 x 25cm (12 x 10in)

The flow of speckled texture that pours from the top of the seed head
loosely implies a flurry of escaping seeds.

▲ **Seed head patterns**

A quick sketch made to plan the tonal values and composition of a painting.

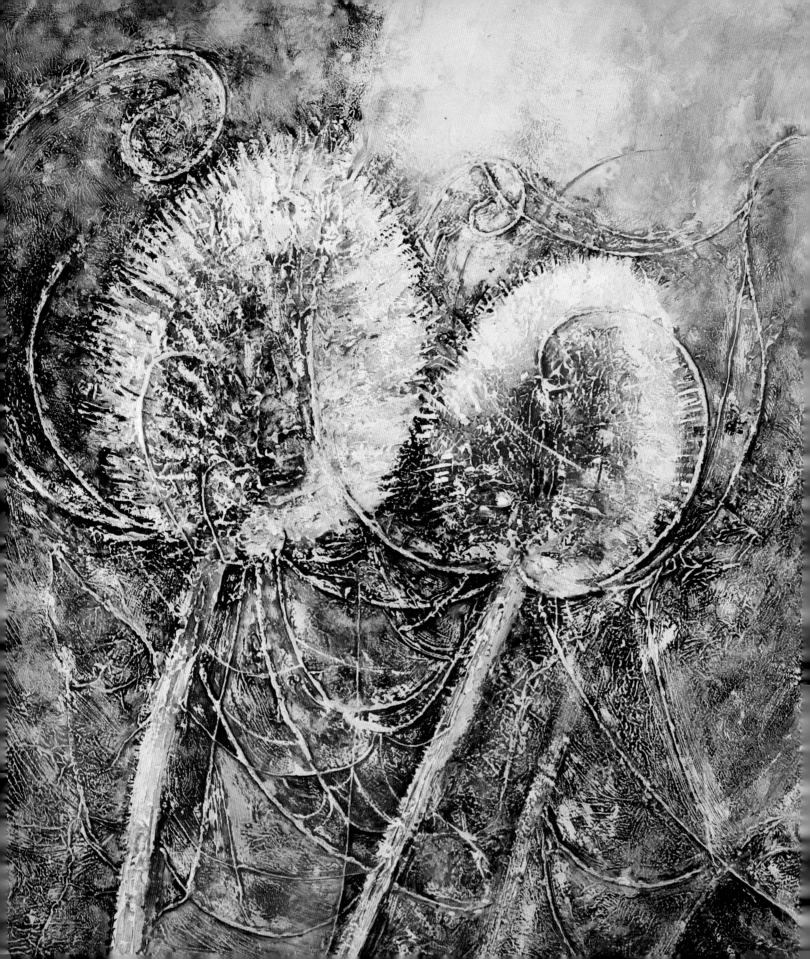

Working with gesso

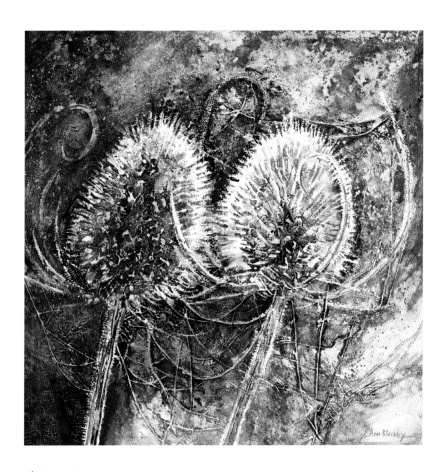

As the translucent petals of summer disappear and are replaced by more solid, sculptural plant forms, I look for new media to express their textural, wintry qualities. Using watercolour on a board that has been primed with gesso results in completely different types of textures and marks from those made on a traditional paper surface.

Creating a textured surface

I generally use mountboard for this sort of work and apply the gesso with coarse or smooth brushes, or tools such as a roller or palette knife. The amount applied and the sort of textured surface made with the gesso will affect the marks of subsequent layers of paint. As this surface is not as absorbent as watercolour paper, I use thicker, more opaque paint and even supplement the watercolour with acrylics or gouache. The paint sinks into the crevices made by the gesso and can easily be wiped away to create further marks. Crumpled tissue paper or collage can be stuck to the board before it is primed with gesso to increase the textural effect even further.

◀ **Wintry Teasels**
30 x 30cm (12 x 12in)
Here, I worked on mountboard that I had prepared with gesso and tissue paper. I also used thick texture paste on the teasel head to create rough, spiky textures. When this was dry I painted on washes of watercolour, followed by further scumbled layers of gouache.

▲ **Frosty Teasels**
30 x 30cm (12 x 12in)
I painted a second version of teasels, applying dry white gouache on the raised gesso areas to suggest frost. I also rubbed a little bit of silver paint over parts of the painting to give it an icy winter shimmer.

Winter skeletons

When winter plants have been reduced to their bare skeletons it is a great time to concentrate on the abstract qualities of their shapes. Stalks, stems and seed heads are often seen at this time of year as dramatic silhouettes, either ghostly pale against a dark backdrop or vice versa. Winter hogweeds create wonderful intricate patterns, with their stark umbrella shapes. As my flower-painting year was drawing to an end, I realized that they offered the perfect opportunity for experimenting with some of the new thoughts and ideas that I had been hatching through the seasons.

Developing abstract qualities

I painted *Winter Hogweed* on a surface prepared with gesso applied with a coarse house painter's brush. I had stuck strips of paper to mountboard first to suggest or echo the shapes of stalks. I had also stuck some of the actual seeds from the hogweed plant onto the surface, using texture paste as a thick glue to make sure that they were properly embedded in the surface. I primed these collage additions with another layer of gesso before painting on top. I decided to paint diagonal strips using acrylic inks around the main hogweed area to emphasize the linear quality of the plant and give a semi-abstract feel to the painting.

I continued this theme of abstract pattern with another version, *Hogweed: Lines and Gaps*, in which I examined the triangles and geometric designs created by the overlapping plant skeletons.

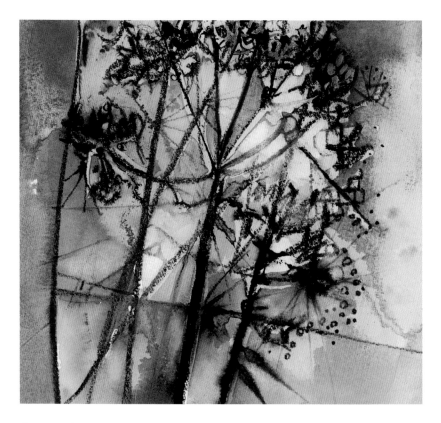

▲ **Hogweed: Lines and Gaps**

18 x 21 cm (7 x 8¼ in)

Here, I made a spontaneous drawing using black water-soluble crayon. I drew lines of varying thickness for the stems and represented seeds with circles and dots. I then worked into the geometric gaps with watercolour.

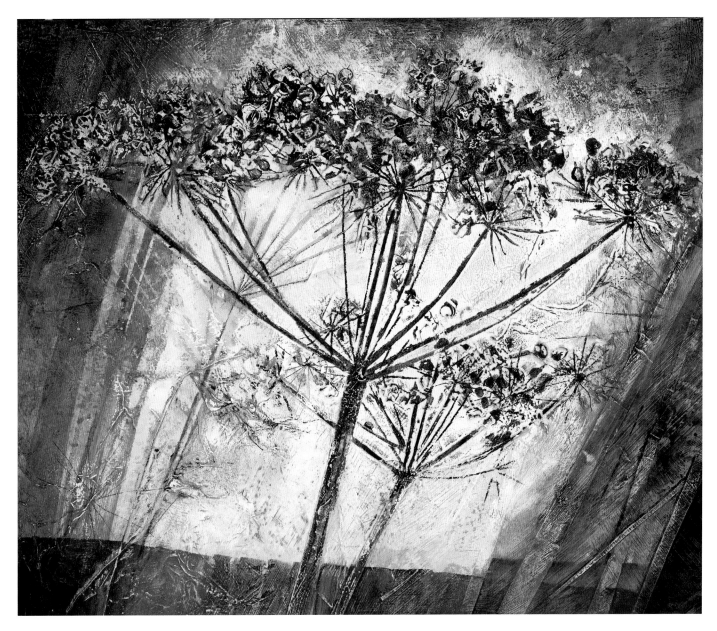

▲ **Winter Hogweed**
29 x 36cm (11 ¹/₂ x 14in)
I used Sepia and Rowney Blue acrylic inks to paint this hogweed. I deliberately chose a
restrained, cool palette to evoke the mood of a cold winter day.

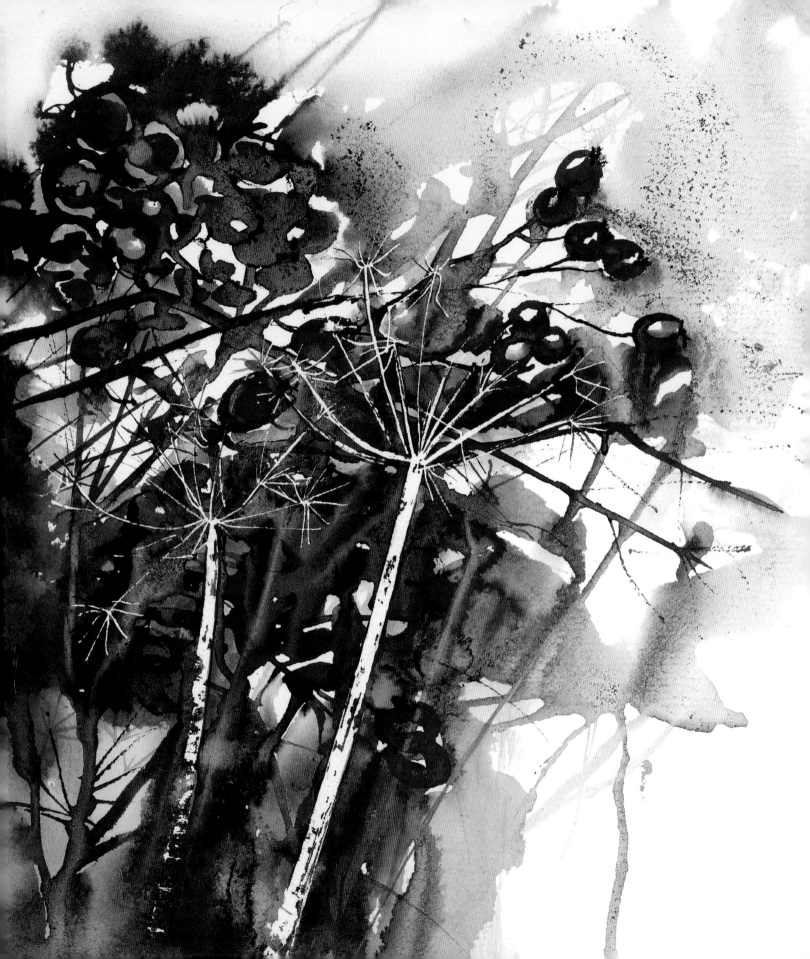

Finding a fresh approach

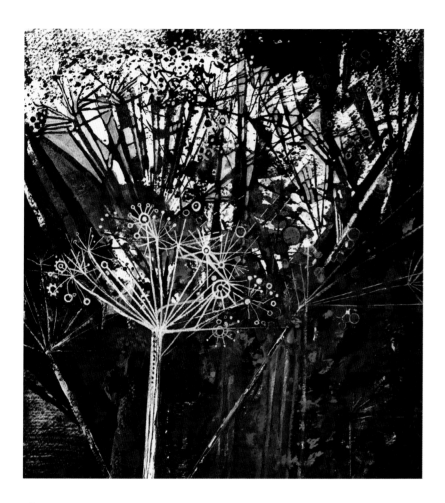

◀ **Black, Blue, Red and White**
32 x 32cm (12³/₄ x 12¹/₄ in)

▲ **Vintage Hogweed**
26 x 23cm (10¹/₄ x 9in)
The decorative elements of this painting are based on some 1950s patterns. The geometry
of the designs seemed to suit shapes seen in the subject. The lines and circular patterns that
I used to represent the seed heads were painted on top of a background with white gouache.

Developing a contemporary style is not just about
finding new techniques. To get away from being
strictly representational or traditional you actually
need to start thinking differently. Lateral thinking
and imagination are required to turn a painting into
a truly original statement. A lot of my
experimenting has been to do with the various
methods that I have used or a particular
combination of materials.

Using different drawing styles

The way that you draw also has an enormous
impact on the finished mode of expression. If the
subject is drawn beautifully but remains absolutely
faithful to the subject in shape, proportion and
detail, it will retain a traditional style. Although
until now I have used an idiosyncratic shorthand
for small parts of a subject, such as the stamens,
leaves, stems or petal patterns, the overall
impression has still remained representational.

In *Black, Blue, Red and White* I painted a hedgerow
pattern of rosehip and hogweed shapes. The
colours are my own invention, but the drawing
is based on real-life observation. The drawing
in *Vintage Hogweed*, on the other hand, is more
quirky. It uses mannerisms and decorative motifs
taken from 1950s prints – a 'retro' style that is
currently fashionable.

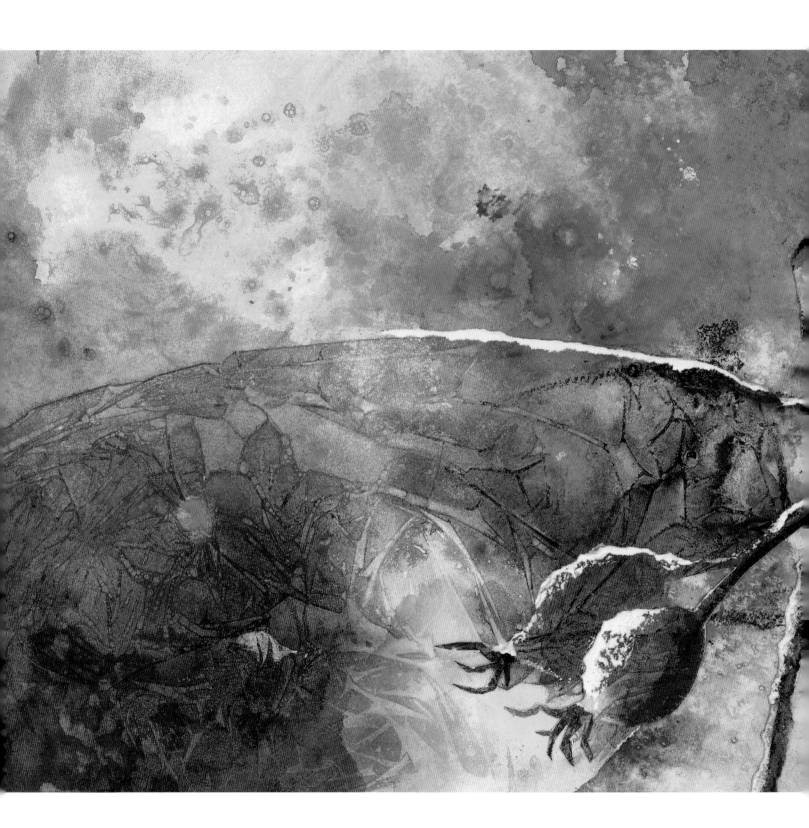

Food for thought

◀ **Frosted Rosehips**
28.5cm x 40cm (11¼ x 15¾in)
I applied salt and clingfilm to a wet wash here to add frosty
sparkles and icy crackles. When the paper was dry I tore off
some pieces, making white ragged edges to represent
dustings of snow on the branches and rosehips.
I reassembled these into an abstract pattern to conjure
up a winter hedgerow fantasy.

▲ **Snow-dusted Rosehips**
21 x 24cm (8¼ x 9½in)
The pattern made by the wild-rose stems divided this
semi-abstract picture into sections. I painted each segment
individually so that they became almost like a series of
miniature winter landscapes.

I have reached the end of my flower-painting year
bursting with fresh ideas. My experiments have
given me lots of new techniques to continue
playing with. Above all, I have reminded myself of
the importance of thinking about *why* I paint
something in a particular way as well as *how* I paint
it. I have realized the need to be imaginative, as it is
imagination and poetic licence that make work
individual. The beginning of the painting process
involves observing a factual subject, but the added
ingredients that are imagined or personal are what
gives the painting its extra dimension.

Involving the viewer

I aim to produce watercolours that are exciting
in painterly terms but which also offer visual ideas
that are thought-provoking in other ways. They
may sometimes be based on ideas that relate to
a personal experience that an onlooker could never
fully understand. However, I like to think that
whoever looks at my paintings might discover their
own stories or landscapes within them, and that
these may be quite different from my own
intention. This particularly applies to the more
impressionistic paintings or within abstract areas of
background where things are not fully explained.
I like paintings to be visually interesting but also to
provide food for thought.

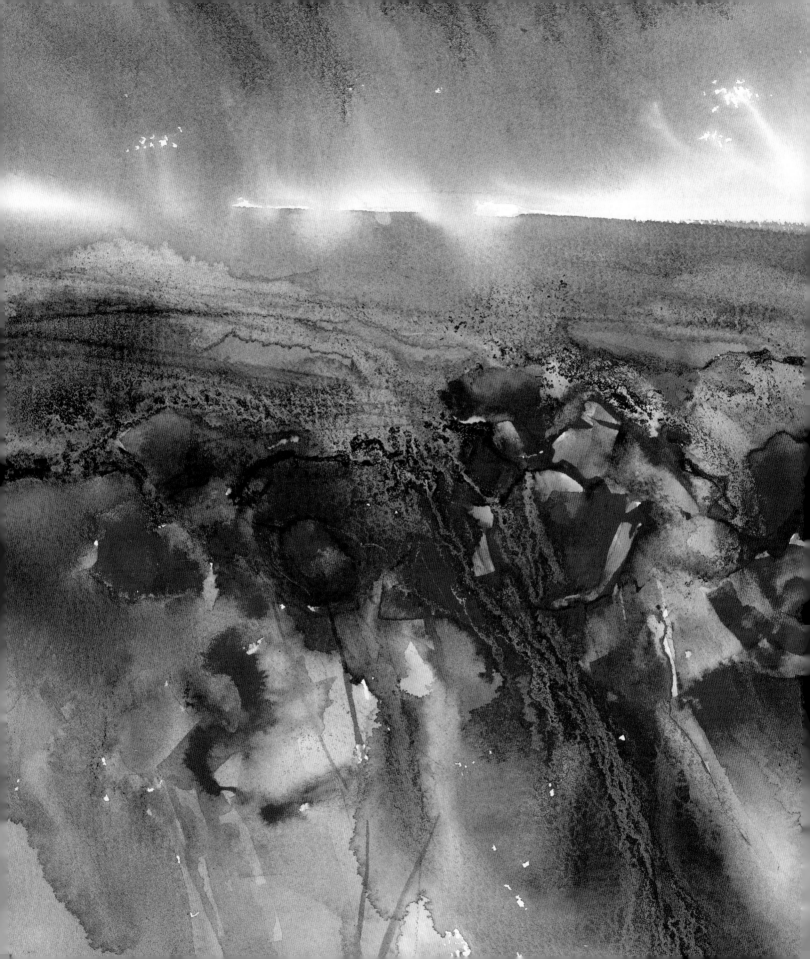

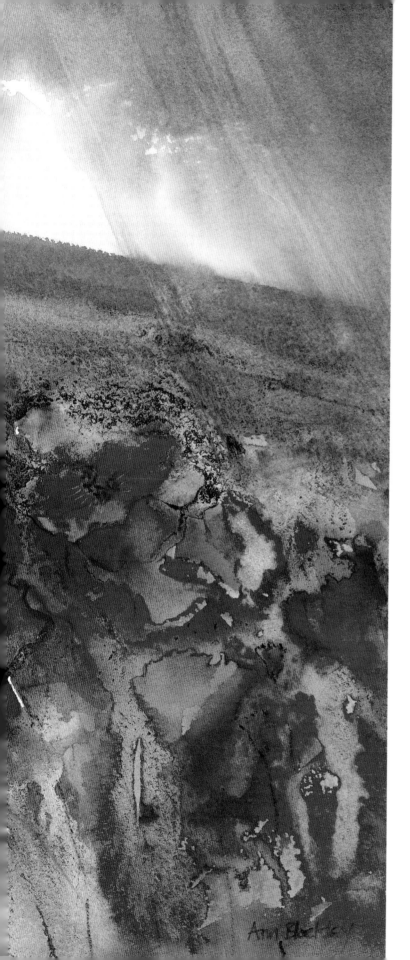

Flowers in the landscape

My backgrounds are as important as the flowers themselves. They are often like little landscapes and realizing this has drawn me to paint wild flowers set in the context of their environment. Fields of colour, hedges of tangles and carpeted woodlands are all atmospheric habitats that provide opportunities to experiment with flowers in a more ambiguous, imaginative way. When flowers lose their individual identities to become part of a bigger picture it is easier to concentrate on their abstract qualities to create even more impressionistic interpretations.

◀ Poppy Field
25 x 33cm (10 x 13in)

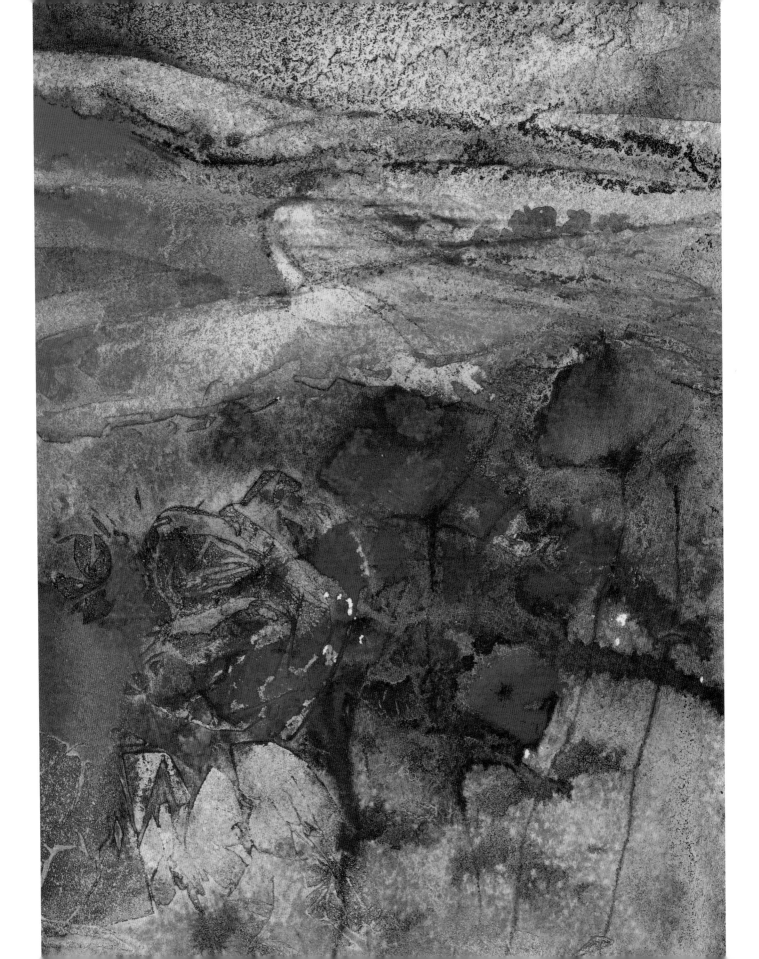

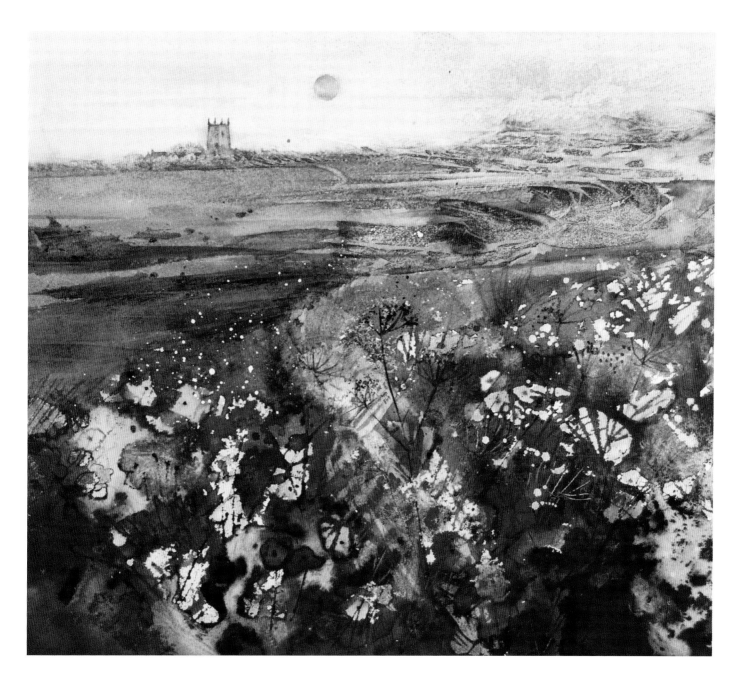

◀ **Near and Far**

18 x 14cm (7 x 5¹⁄₂ in)

This was painted from memory after walking through a poppy field by some rolling hills. I deliberately kept it vague, like something remembered in a dream, with smudgy edges and soft marks.

▲ **Church View**

19 x 23cm (7¹⁄₂ x 9in)

This painting started life as an abstract watercolour, created with no plan other than to enjoy the pleasure of mark-making. I put it to one side and saw later that by adding a few details its reddish tints and textures might suggest poppy-like flowers within a landscape. I added the distant church and a setting sun to evoke a feeling of time and place.

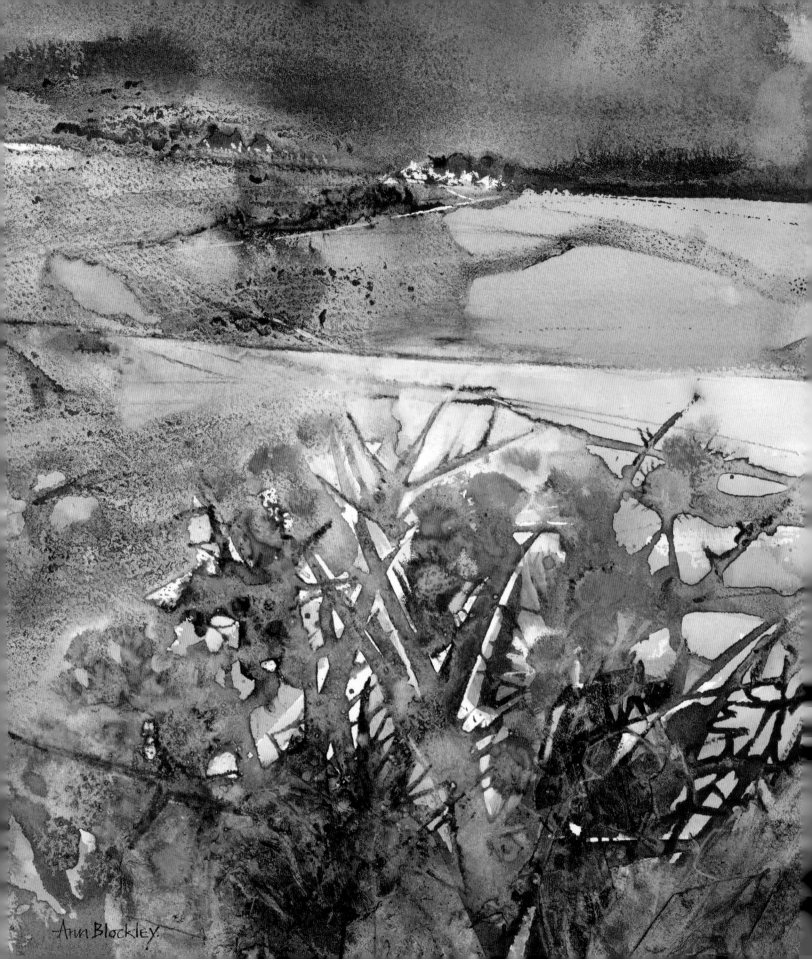

Ann Blockley.

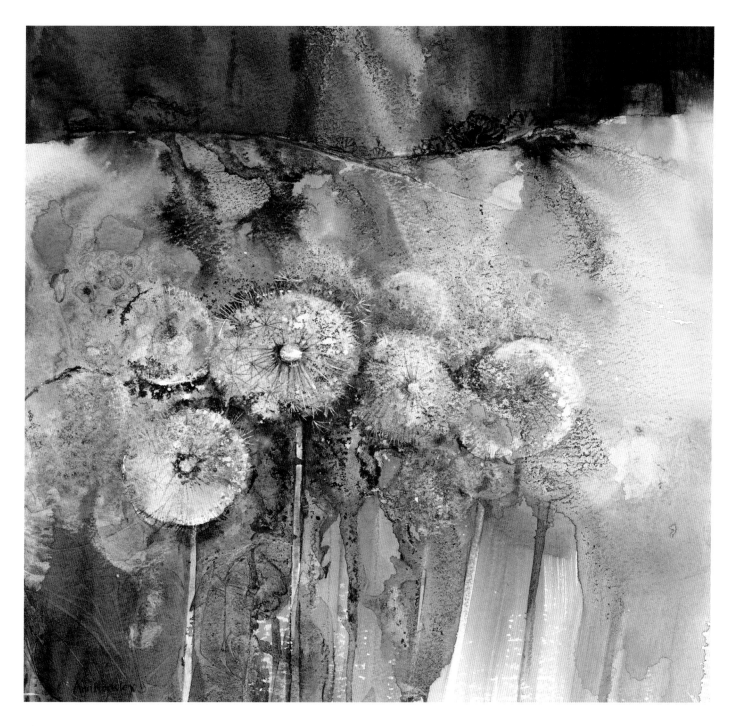

◀ **Thistle Landscape**

32 x 26cm (12½ x 10¼in)

I painted this from imagination. I enjoyed the idea of the spiky thistle leaves echoing the zigzag lines in the landscape, which lead the eye to what seems to be a small hamlet but may simply be little paint marks!

▲ **Once Upon a Time**

33 x 32cm (13 x 12½in)

This has an air of mystery, with its dark, sombre tones and areas of moonlight breaking through the sky. Some pale rectangles on the skyline may or may not be strange buildings – a castle perhaps?

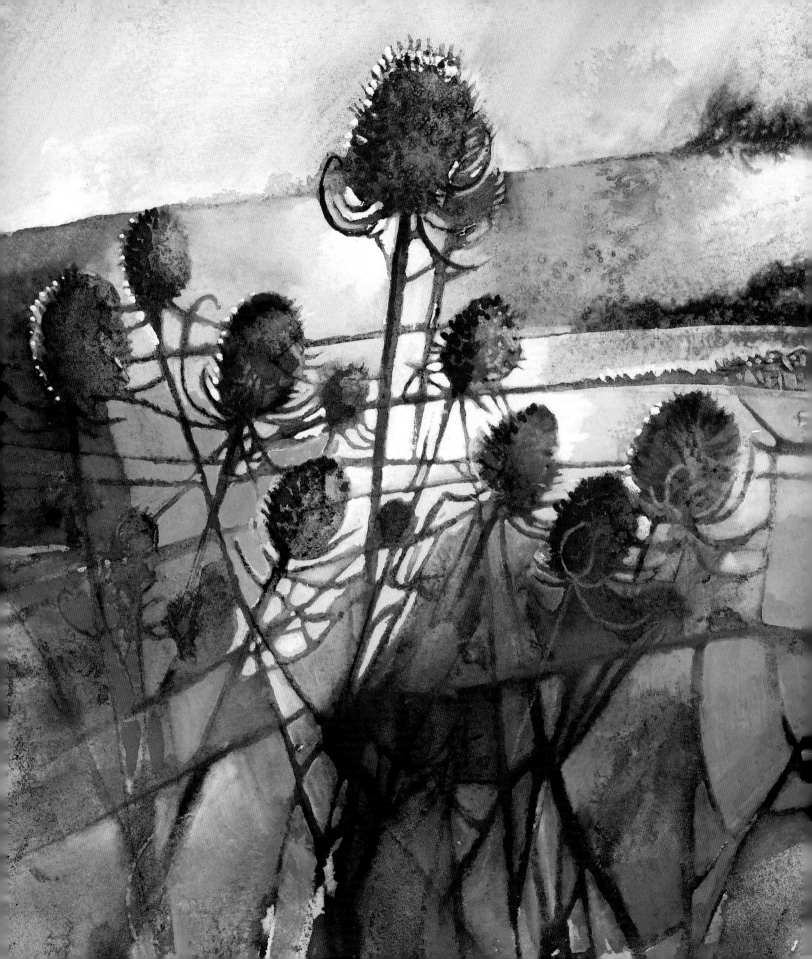

◀ **Teasel Time**

24 x 29cm (9½ x 11½in)

A group of winter teasels formed a geometric tangle of stalks, spikes and tendrils. Snow emphasized the patterns and I put them into an imaginary winter landscape, using a combination of gouache and watercolour. The positive and negative shapes made an abstract design that linked the teasels with the patchwork pattern of a snow-sprinkled landscape behind them.

A Walk in the Snow (pages 122–123)

25 x 42cm (10 x 16½in)

This is quite a traditional watercolour, which I have drawn into with watercolour pencils and to which I added a little salt to create snowy sparkles. The small circles and dots of white gouache that indicate gaps between the teasels are the focal point, and these are also my shorthand method of describing the drops of snow clinging to the plant spikes.

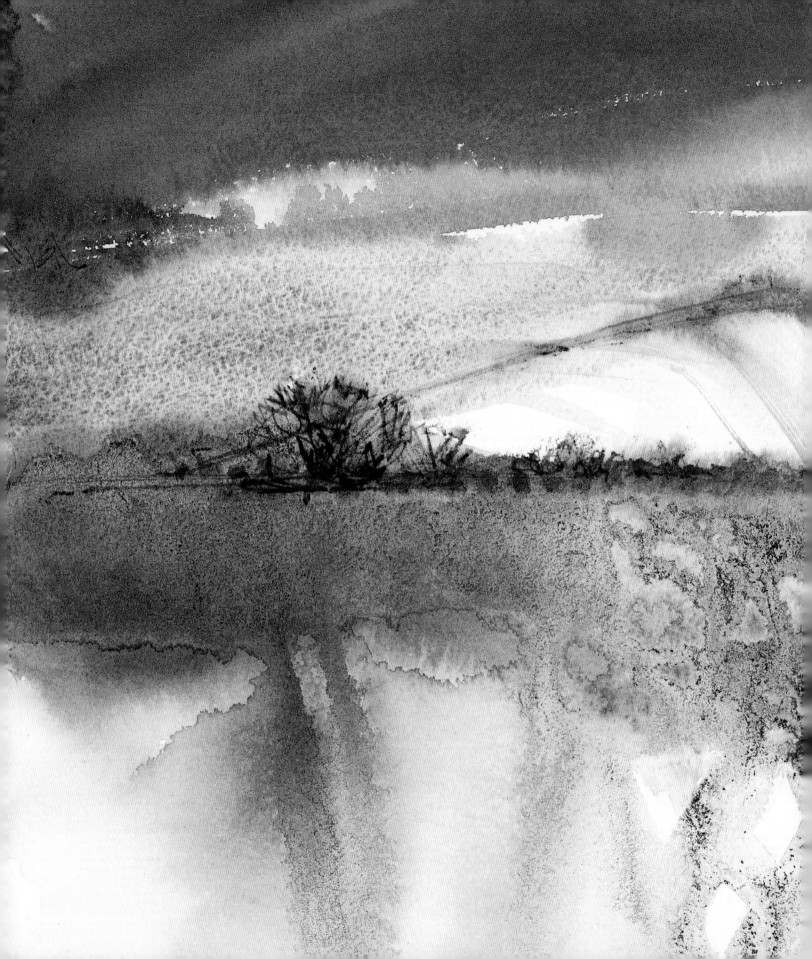

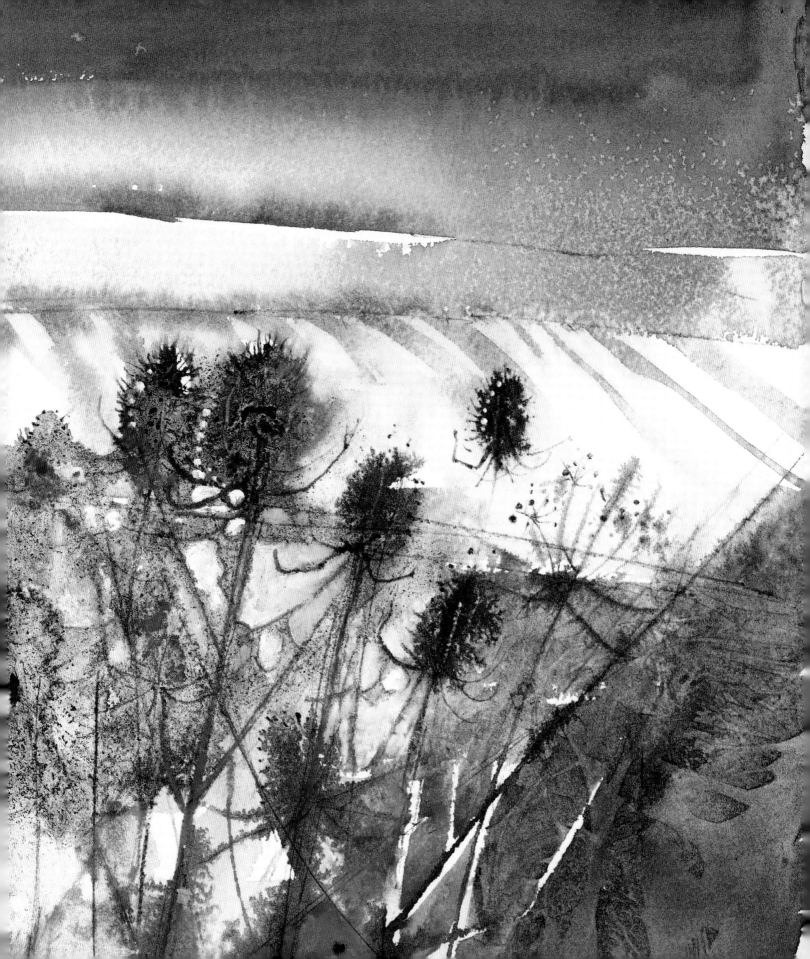

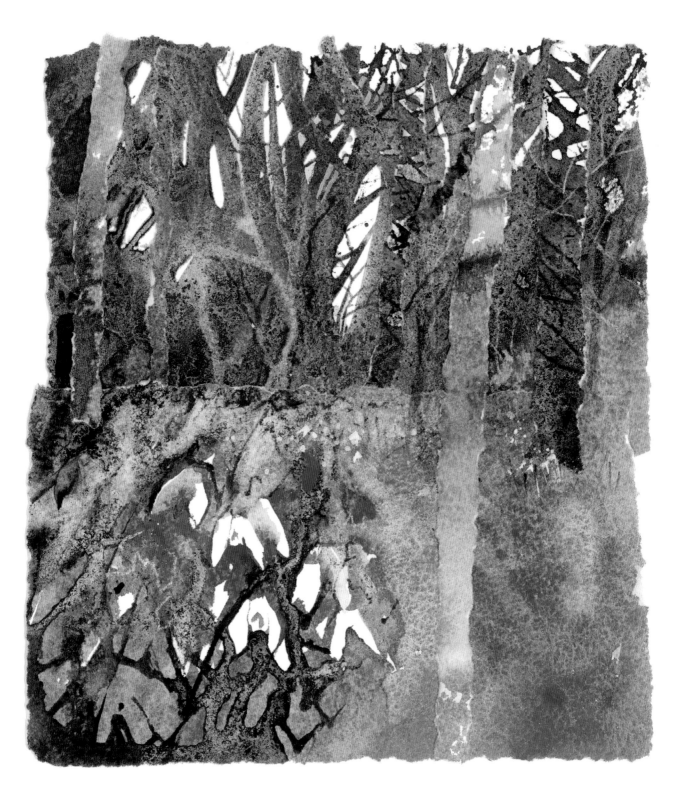

▲ **Snowdrops in the Wood**

19 x 17cm (7¹/₂ x 6¹/₂ in)

I painted a loose watercolour, leaving patches of white to describe sketchy snowdrops and the gaps between trees. I stuck strips of painted paper on top to suggest a semi-abstract woodland.

▶ **Walking Through Bluebells**

32 x 30cm (12¹/₂ x 12in)

In this painting, I concentrated on the abstract qualities of shimmering shades of blue against the dappled greens of the woodland using many speckles of paint.

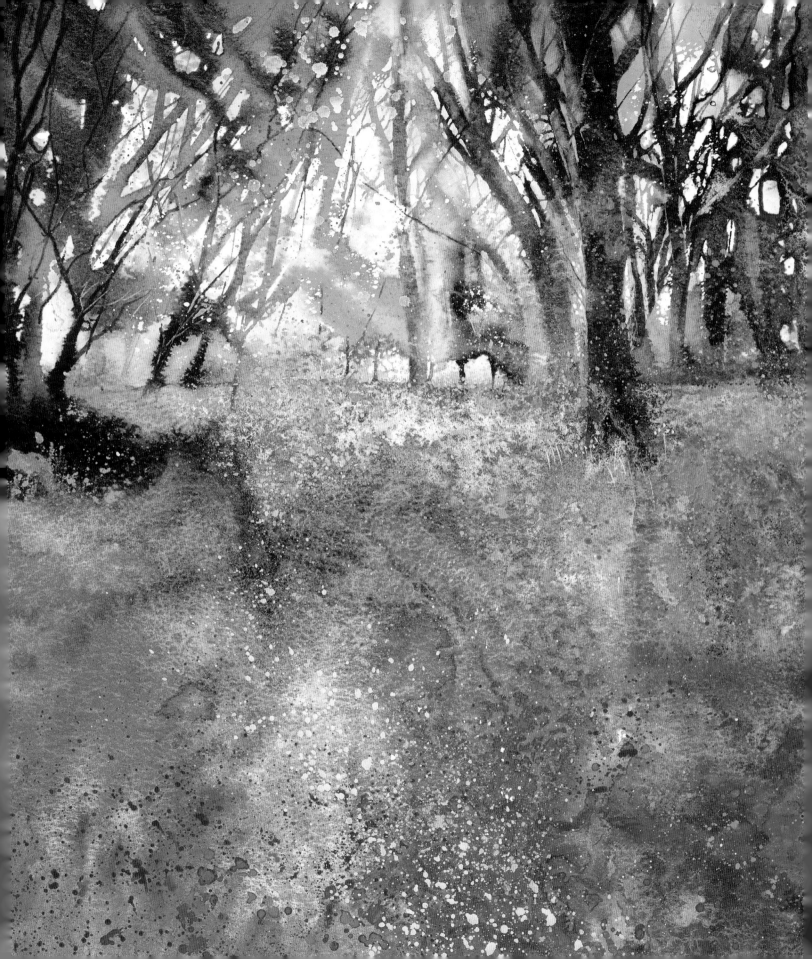

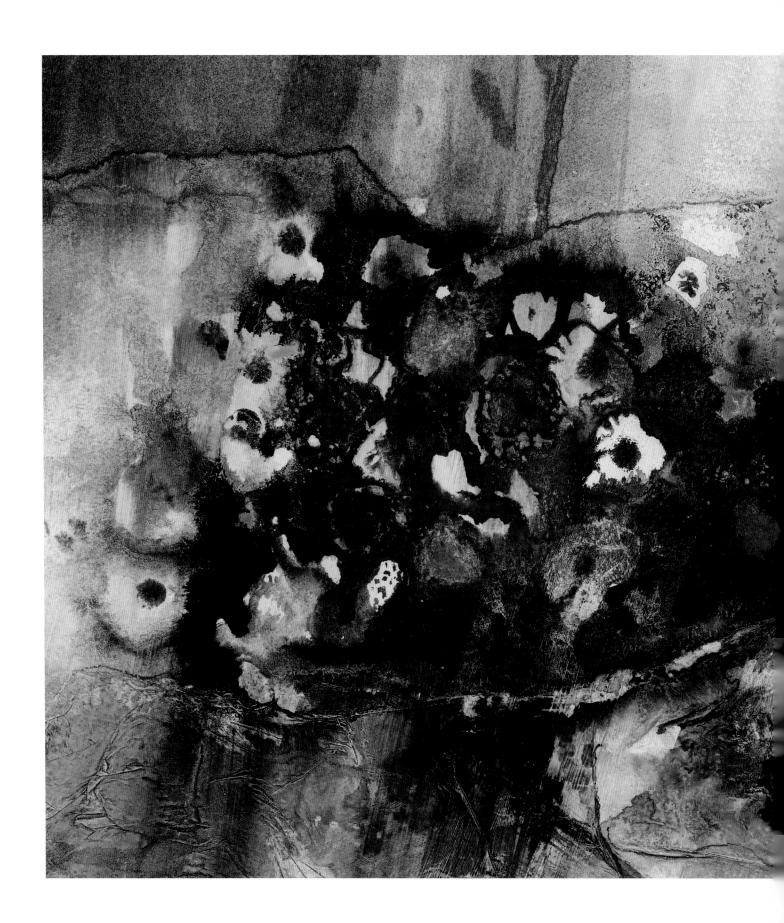

◀ **Chasing Rainbows (detail)**
36 x 29.5cm (14¼ x 11¾ in)
I like the way that this abstract landscape, with its flower
shapes and strange light, evokes all sorts of things without
being too specific. The flowers are a bit like sunflowers, but
remain ambiguous. It gave me the idea of beginning to paint
more flowers from imagination, basing them on reality but
inventing my own new species!

Index